IMAGES
of America

JEWEL CAVE NATIONAL MONUMENT

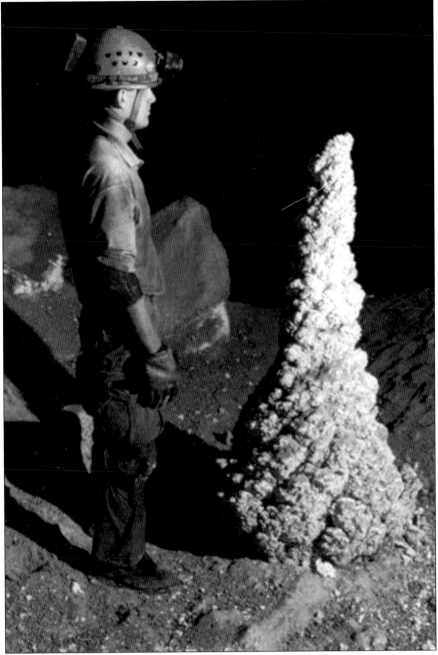

Kelly Mathis, a Jewel Cave seasonal employee and tour guide, confronts a logomite, a type of stalagmite, in 1997. The scene takes place in the Stratosphere, a mazelike area in the upper level of the cave. (Courtesy of Marc Ohms.)

On the cover: Explorers Herb and Jan Conn, in April 1960, stand on the brink of a cavern they called Penn Station, their first glimpse into virgin territory in Jewel Cave. The room was so large it reminded them of a train station. (Courtesy of David Schnute.)

IMAGES
of America

JEWEL CAVE
NATIONAL MONUMENT

Judy L. Love

ARCADIA
PUBLISHING

Published by Arcadia Publishing
Charleston SC, Chicago IL, Portsmouth NH, San Francisco CA

Printed in the United States of America

Library of Congress Catalog Card Number: 2008928996

For all general information contact Arcadia Publishing at:
Telephone 843-853-2070
Fax 843-853-0044
E-mail sales@arcadiapublishing.com
For customer service and orders:
Toll-Free 1-888-313-2665

Visit us on the Internet at www.arcadiapublishing.com

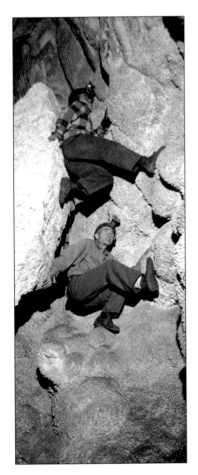

Originally from the east, Herb and Jan Conn opted to turn down lucrative careers to live simply, holding part-time and seasonal jobs to meet expenses. They settled in the Black Hills because the area offered opportunities for rock climbing, their first love. The couple made more than 700 exploratory trips into the cave and surveyed and mapped some 64 miles of passages. (Courtesy of David Schnute.)

CONTENTS

ACKNOWLEDGMENTS

This book would not have been possible without the many people who helped and encouraged me. Thanks to my husband, Dave, for his support and for taking over more than his share of chores. I am grateful to Herb and Jan Conn, Dwight Deal, Mike Wiles, Dennis Knuckles, Steve Baldwin, Art Palmer, and Al Hendricks, all of whom shared with me their exploring stories, explained various aspects of cave science, and patiently answered a sunlight and surface lover's many questions. Thanks to Todd Suess, Jewel Cave superintendent, for his cooperation in allowing me to interview staff members and review the Cultural Landscape Report/Environmental Assessment Study and Place of Passages the Historic Resource Study, recently prepared for the park. The photographs, which so enhance the story of Jewel Cave, were provided by David Schnute, Mike Wiles, Marc Ohms, Steve Baldwin, Herb and Jan Conn, curator Bruce Wiesman and his archival staff at Mount Rushmore National Memorial, Paul Horsted, Phil Geenen, Martha Studt, Miriam Gola, the Michaud family, Dorothy Delicate, and the Custer County 1881 Courthouse Museum. Don Lytle and Carl Gola generously took the time to come to my home and provide information on construction of the tour routes. Harrington Studio and Wildcat Computers, both of Custer, helped with my photograph scanning and computer problems. Finally, thanks to my editor, Anna Wilson, and author Peggy Sanders for their advice and support.

INTRODUCTION

In the spring of 1900, Frank and younger brother Albert Michaud stumbled upon a little hole at the base of a cliff that would alter the course of their lives. They were exploring Hell Canyon in the Black Hills of South Dakota. Like their father some 25 years earlier, they had come to the area in the hope of doing a little prospecting.

Born in Quebec Province, Canada, Felix Michaud moved to Wisconsin and later to Colorado, where he raised a family. After his wife died in 1875, Michaud left his children in the care of relatives, and with thousands of other men joined the Black Hills gold rush. He settled in the town of Custer and remained for 30 years, making a living by mining and ranching.

Frank and Albert were not far from Custer that morning when they rode their horses through the canyon to "look things over." According to Frank's son, Ira, the brothers heard a "strange sound, loud and shrill" coming from the north wall of the canyon. They dismounted and followed the noise to its source. It was wind roaring from a small hole in the limestone. Intrigued, they tried unsuccessfully to enlarge the opening so that they could squeeze inside. They made a trip to Custer to buy tools and blasting powder and then returned to the canyon to find that the wind then was being sucked into the hole. Changes in barometric pressure cause the cave to "breathe" in and out like a living organism. When the Michauds chiseled, hammered, drilled, and blasted their way into the cavern they found passages lined with sparkling, multifaceted calcite crystals. They named their find Jewel Cave.

Today Jewel Cave National Monument covers 1,275 acres of pine forest, gouged by two steep canyons, Hell Canyon and Lithograph Canyon. Rugged and rocky, the park offers spectacular views of the southern Black Hills. The cave lies in a 450-foot-thick layer of rock known as the Pahasapa Limestone. Over that is the Minnelusa Formation, which consists mostly of sandstone. The caverns were formed by water dissolving limestone along fractures in the rock. Cave development was enhanced when the rise of the Black Hills caused uplifting and cracking of the rock layers. In addition to the crystals, the cave boasts some rare speleothems, including scintillites and hydromagnesite "balloons," as well as more common formations, such as stalactites, stalagmites, and frostwork.

Today it is an easy drive to the park from Custer, 13 miles to the east, or from Newcastle, Wyoming, some 25 miles to the west. But in Frank and Albert's day it was a lengthy trip by horseback or horse-drawn wagon.

According to family history, the Michaud brothers wrote to relatives that they had found an "underground wonderland." A family friend, Charles Busche, came from Colorado to become a partner in the venture. The trio, along with Felix Michaud, filed a location certificate in Custer

on October 31, 1900. The certificate gave the partners the right to mine the cave, which was located on U.S. Forest Service (USFS) land.

Others later claimed to have been inside the cave before the Michauds. They include Burdette Parks, a cowboy who said he had entered the cave in 1886 and removed a wagonload of crystals, and one John or Dick Wells, who also was said to have been in the cave that year. It is most likely that these stories actually involve other, smaller caves, since there are many in the area. At any rate, it was the Michauds and their partner who first explored and developed Jewel Cave.

They hoped to turn the cave into an attraction, creating a new and larger entrance, which they reinforced with heavy timbers, and blazing a trail to the cave entrance from the Custer-Newcastle road. They built an attractive log house to provide lodging for travelers and even operated a dance club at the site. But things did not go well for the Michauds and Busche. Because there was no public transportation to the cave and the roads were poor, few sightseers came. And, according to Ira Michaud, some local businessmen debunked the cave.

In 1904, in an attempt to gain ownership of the cave, the partners applied for a patent to their mining claim. The Department of the Interior turned them down. Possibly the agency questioned the validity of the claim since the cave was not being mined. The following year, Charles Busche sold his interest in the cave to the Michauds and moved away. Felix, too, left the Black Hills for British Columbia. Frank and Albert welcomed a new partner, Bertha Cain, of St. Louis, Missouri. Also in 1905, Frank married Mary "Mamie" Riley of Custer. With their new partner, the Michauds applied again for the patent that year and in 1906 but without success.

Meanwhile, the USFS conducted a study on Jewel Cave. The study recommended that the land remain under its management and proposed that both Jewel Cave and nearby Jasper Cave be included in a new national monument. On February 7, 1908, Pres. Theodore Roosevelt signed a proclamation, creating Jewel Cave National Monument, citing the caves' scientific interest.

The issues of the Michauds' claim and restitution for the money they had invested in the cave remained unresolved for years. The brothers and Bertha Cain wrote numerous letters to government officials, studies were done, and reports were filed, but no settlement came. In 1911, Albert gave up his interest in the business and left the Black Hills. To raise funds and, possibly, to keep his claim valid, Frank sold several tons of rock specimens to a priest in West Bend, Iowa, who used them in building a Catholic church and a shrine, the Grotto of the Redemption. Although Jewel Cave had been declared a national treasure, Congress failed to allocate money to develop it.

In the 1920s, automobiles became affordable for many Americans, and motoring became a national pastime. Vacationers came to the Black Hills to visit Custer State Park and Wind Cave National Park, near Hot Springs, and enjoy the outdoor recreational activities the area has to offer. While the Michauds continued to lead tours into the caverns, without government funding and direction they could do little to maintain it. For years, the entrance gate remained locked most of the time.

The Michauds were not alone in seeing the cave's possibilities as a tourist attraction. Custer community leaders long had pressed government officials to develop it. After Frank Michaud's death in 1927, a group of businessmen from Custer and Newcastle persuaded the government to issue it a permit to operate the cave. The group formed the Jewel Cave Corporation and sold stock to raise money to both develop the cave and settle the Michaud claim. Frank's widow, Mamie, needed money to support her family and agreed to sell her title to the cave. For her family's 30 years of work in the cave she received $300 on signing over her claim and, later, an additional $200 from the corporation. The businessmen renovated the cave trails and facilities and reopened the cave for tours.

Government officials, on the other hand, showed little interest in the cave. Roger W. Toll, then superintendent of Yellowstone National Park, reported in 1929 that Jewel Cave was beautiful but of only local interest. Then, on June 10, 1933, all national monuments, including Jewel Cave, were transferred from the USFS to the National Park Service (NPS). The superintendent

of Wind Cave National Park took over operation of Jewel Cave and stationed a ranger there, although the Jewel Cave Corporation continued to furnish tour guides until the end of the 1939 season.

Also in 1933, the Civilian Conservation Corps (CCC), one of Pres. Franklin D. Roosevelt's New Deal programs, was created. Designed to encourage economic recovery after the Great Depression, the CCC undertook construction projects in national and state parks, creating jobs for thousands of unemployed young men. A small group of CCC enrollees from the Wind Cave unit arrived at Jewel Cave in May 1935 to establish a "side camp." During their four years at the national monument, the workers were responsible for tremendous improvements, including the construction of a headquarters building near the cave entrance, a 3,000-gallon water reservoir with a pipeline connecting it to a spring and a branch line to their camp site, and a cesspool and sewer system. In addition, the corps men worked on new trails, stairways, roads, and fencing and planted shrubbery.

The United States' involvement in and eventual entry into World War II brought an end to the New Deal building programs, including those in the parks. Throughout the war years and for the next two decades, Jewel Cave saw few changes.

While on the surface major improvements had been made, the cave itself had received little attention. During the 1940s, ranger Lyle Linch did some exploring beyond the established tour route. In 1957, while inside the cave, ranger Pat Ryan noticed that his cigarette smoke was being drawn into a pile of rubble. He and two companions cleared away the rocks and dug their way into an unknown chamber. Others, including ranger Dick Hart; William Eibert; Delmer Brown, a student at the South Dakota School of Mines; and Stan Arlton, a teacher at the school, explored and surveyed in the cave. Arlton took barometric pressure readings and theorized that there was much more cave beyond the known boundaries.

By 1959, only about one and a half miles of cave had been explored. A sign outside the entrance almost apologetically informed visitors that "Jewel Cave is a small cave, but the tour is exciting." It was not until geologist Dwight Deal, then a college student, introduced Herb and Jan Conn to the cave that its true significance came to light. Originally from the east, the Conns had come to the Black Hills to pursue their greatest passion, rock climbing. Although they first entered the cave reluctantly, according to Deal, they were grabbed by the adventure of seeing what no one else had seen and of pushing on without knowing what lay ahead. The husband and wife team obtained a special use permit to explore, survey, and map the cave. With other avid cavers, including Wind Cave ranger David Schnute and Karen and Larry Dilts, they made numerous trips into virgin territory. In pursuit of the mysterious wind, they mapped some 64 miles of cave.

The discovery of a vast tangled maze of underground passages led to a redrawing of the monument's boundaries and a land swap between the NPS and Black Hills National Forest. It also paved the way for needed changes. Although increasing visitation made the existing facilities inadequate and park officials had drawn up plans for a new headquarters and other improvements, Congress had not appropriated the funding. That changed after park employees and the Conns developed a new tour route and proposed a new entrance that would take sightseers to some of the spectacular rooms they had discovered. Drilling into the hillside for the new entrance and elevator shaft began in 1964, followed by construction of cave trails and a visitor center, which was completed in 1972.

Friends of another School of Mines student, Mike Wiles, talked him into accompanying them to a program on caving given by Jan Conn in 1978. The lecture, pictures, and "cave songs," which Jan had composed and sang, convinced Wiles that he, too, "had to go caving." After he met the Conns, they became his mentors at Jewel Cave. Wiles started working part-time at the cave and later became its full-time cave management specialist, a title he still holds. By the early 1980s, Herb and Jan had turned over their mantle to Wiles and other younger cavers.

In August 2000, an arsonist started a blaze that consumed nearly 84,000 acres of timber and threatened Jewel Cave. The Jasper fire destroyed almost the entire exterior of the monument,

but no buildings were lost. A law enforcement officer with the USFS, Phil Geenen of Custer, conducted an investigation that led to the arrest of a Newcastle woman.

The national monument, now independent from Wind Cave, celebrates its 100th anniversary in 2008. According to current superintendent Todd Suess, there will be special programs, including an employees' reunion, throughout the year. Other plans for the near future include more exhibits, a new facility at the original entrance in the "historic area," and a shuttle service between the historic area and visitor center.

Now 142 miles long, Jewel Cave is the second-longest cave in the world. But according to Mike Wiles, researchers believe that there may be several thousand more miles of unexplored passages and chambers. The Michauds' find may have been derided by some contemporaries, but the brothers were right when they said they had discovered an underground wonderland.

One

A HOLE IN THE LIMESTONE

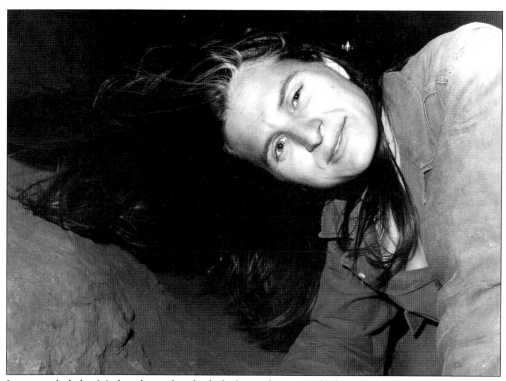

Just as it led the Michauds to that little hole in the ground, the wind beckons cave explorers to push farther and farther into the depths. Differences in air pressure above and below ground cause air to rush in and out of the cave at speeds of 15 to 35 miles per hour. Karen Dilts's hair is blown wildly in a windy passage. (Photograph by Larry Dilts; courtesy of Herb and Jan Conn.)

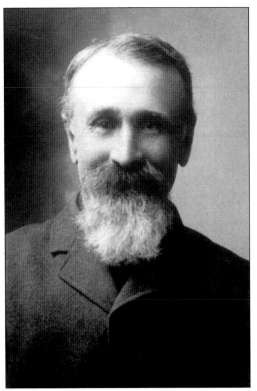

Felix and his wife, Margaret Jane Michaud, had five children, Edward, Annie, James "Alfred," Francis (Frank), and Albert. After Margaret Jane died, Felix (pictured here) headed in 1875 for Wyoming in the hope of earning enough income to provide for his family. At Fort Laramie, he joined a motley crew of prospectors and buffalo hunters on their way to the Black Hills. A year earlier, Gen. George A. Custer had led an exploratory expedition into the area and discovered gold. (Courtesy of the Michaud family.)

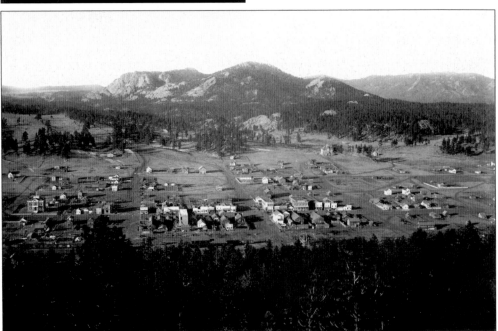

Felix Michaud filed a number of mining claims, but he also ranched and for a while operated a livery stable in the town of Custer. The town grew around the mining camps. The photograph depicts Custer as it appeared about 1890. (Photograph by Fern Strickland Lewis; courtesy of the Custer County 1881 Courthouse Museum.)

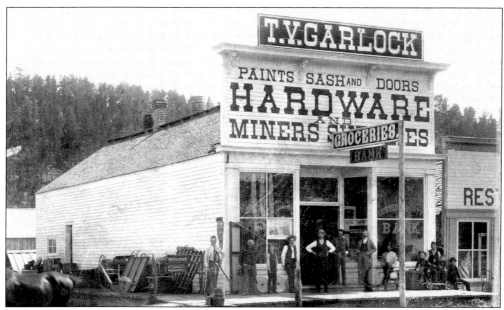

This 1880s photograph taken on Custer's main street shows local businessmen in front of the Garlock building. The enterprise was a combination hardware store, grocery, and bank. Seventh from the left is Tom Delicate, bank cashier and the treasurer of a mining company. He later had a hand in the development of Jewel Cave. (Courtesy of the Custer County 1881 Courthouse Museum.)

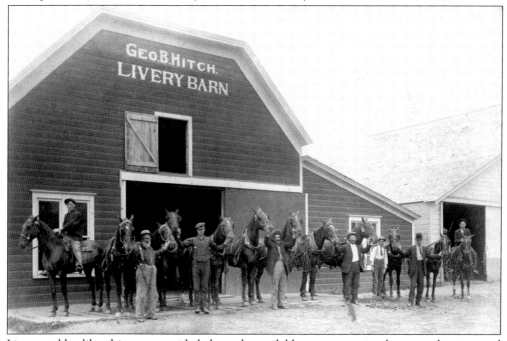

Livery stables like this one provided the only available transportation between the cave and town. Unlike Wind Cave, located south of Custer near the town of Hot Springs, Jewel Cave was not on the route of any train or stagecoach line. Understandably, few sightseers made their way to the cave until the automobile arrived on the scene. (Photograph by Ruth McLaughlin Morris; courtesy of the Custer County 1881 Courthouse Museum.)

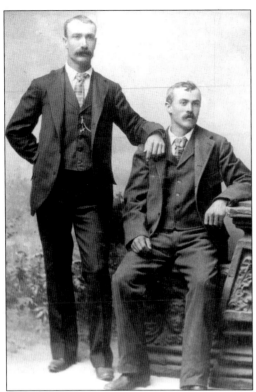

Frank (left) and Albert Michaud are pictured here about 1890. For a brief period, Frank worked a claim in the Klondike gold fields in Canada. After returning to the United States, he met up with Albert in Libby, Montana, where their sister, Annie, and her husband ran a hotel. The brothers worked as cowboys for a while on a Wyoming cattle ranch before heading to the Black Hills. (Courtesy of the Michaud Family.)

The brothers were prospecting in Hell Canyon, located between Newcastle and Custer, when they discovered the cave. They enlarged the hole, which had a diameter of about 24 inches, so they could enter. Later they created a new entrance, reinforcing it with timbers. The historic entrance may be seen in the center of this photograph. (Courtesy of the National Park Service, Jeca 1655.)

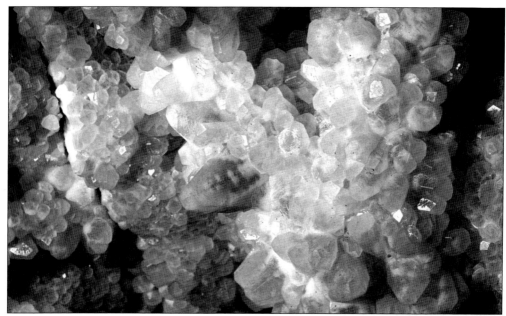

When the young miners squeezed inside, they found passages lined with dazzling calcite crystals like these. Water entering the cave deposited an extensive coating of calcite, which then crystallized, on the walls. Other types of crystal, including aragonite, selenite, and unique scintillites, fingers of eroded chert coated with quartz, also are found in the cave. (Courtesy of David Schnute.)

Because the cave was located on U.S. Forest Service (USFS) land that could not be purchased, the Michaud brothers and a partner, Charles Busche, filed a location certificate, which gave them mining rights. They built a large log house at the cave site to serve as a hotel for the tourists they hoped to attract. An early visitor, Vern Morris, is seen here in front of the hotel. The Michaud homestead was located about six miles east of the cave on Lower Lightning Creek. (Courtesy of the National Park Service, Jeca 1803.)

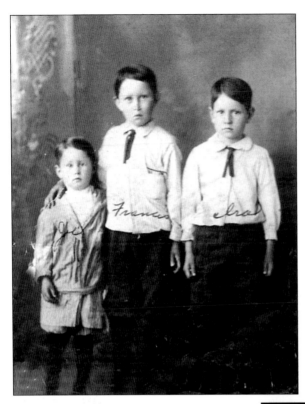

In 1905, Frank Michaud married Mary "Mamie" Riley of Custer. The couple had three sons, (at left, from left to right) Joe, Francis, and Ira, and (below) twin daughters, Mary and Marie. The boys worked in the cave, helping their father and uncle Albert build wooden ladders that would allow visitors access to the scenic rooms. Francis would remain in the Black Hills, while his siblings eventually moved to other areas. But Ira retained a strong bond to the cave. (Courtesy of the Michaud family.)

Visitors had to climb down three sections of ladder through a large crevice to see the spectacular formations in the Madonna Room; the Michauds anchored the ladder sections to heavy timbers to secure them and built a viewing platform at the top of the bottom ladder. With a little imagination, visitors could see the Virgin Mary and the Christ child in the rocks. (Photograph by John St. Clair; courtesy of the National Park Service, Jeca 75.)

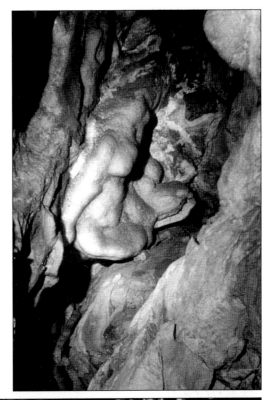

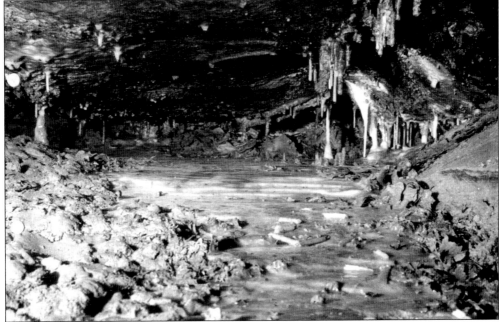

The Michauds guided sightseers through about one half mile of cave passages. The tour went as far as Milk River (pictured here) on one route and the Big Room on a second route. Later explorers would find a lead to take them beyond Milk River into unknown cave. (Photograph by John St. Clair; courtesy of the National Park Service, Jeca 73.)

By the President of the United States of America

A Proclamation

WHEREAS, the natural formation, known as the Jewel Cave, which is situated upon the public land, within the Black Hills National Forest, in the State of South Dakota, is of scientific interest, and it appears that the public interests would be promoted by reserving this formation as a National Monument, with as much land as may be necessary for the proper protection thereof;

Now, therefore, I, THEODORE ROOSEVELT, President of the United States of America, by virtue of the power in me vested by section two of the Act of Congress, approved June eighth, nineteen hundred and six, entitled, "An Act For the preservation of American antiquities," do proclaim that there are hereby reserved from settlement, entry, and all forms of appropriation under the public land laws, subject to all prior valid adverse claims, and set apart as a National Monument, all the tracts of land, in the State of South Dakota, shown as the Jewel Cave National Monument on the diagram forming a part hereof.

The reservation made by this proclamation is not intended to prevent the use of the lands for purposes consistent with the withdrawal made by this proclamation, or for forest purposes under the proclamation establishing the Black Hills National Forest, but the two reservations shall both be effective on the land withdrawn, but the National Monument hereby established shall be the dominant·reservation.

Warning is hereby given to all unauthorized persons not to appropriate, injure, or destroy any feature of this National Monument or to locate or settle upon any of the lands reserved by this proclamation.

In Witness Whereof, I have hereunto set my hand and caused the seal of the United States to be affixed.

DONE at the City of Washington this 7th day of February, in the year of our Lord one thousand nine hundred and eight, and of the Independence of the United States the one hundred and thirty-second.

[SEAL.]

THEODORE ROOSEVELT

By the President:
ELIHU ROOT
Secretary of State.

[No. 799.]

Although the discoverers and their partners applied repeatedly for a patent that would have given them title to the land, USFS officials turned them down, preferring to keep the cave in the public domain. After Wind Cave became the nation's eighth national park in 1903, local entrepreneurs looked with renewed interest at Jewel Cave. The Michauds, possibly in collaboration with others, promoted the establishment in the national forest of a federally administered wild game preserve, which would have included Jewel Cave, and in 1906, a petition to create such a game park began circulating in the Black Hills. However, the same year Congress passed the Antiquities Act, allowing the president to proclaim objects of historic or scientific interest "national monuments." Acting on the USFS's recommendation, on February 7, 1908, Pres. Theodore Roosevelt issued a proclamation creating Jewel Cave National Monument. (Courtesy of the National Park Service, Jeca 07.)

Although the presidential proclamation stipulated that creation of the national monument was subject to "all prior valid adverse claims," the government failed to settle the Michaud claim. After Albert Michaud and Charles Busche left the Black Hills, Frank Michaud struggled to keep the cave open until ill health forced him to give up. He died on February 16, 1927, while visiting family in British Columbia. (Courtesy of the National Park Service, Jeca 04.)

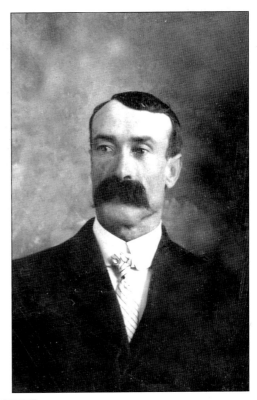

In a 1989 interview with a National Park Service official, Ira Michaud recalled an incident that occurred when he was about six years old. A couple who had just gone through the cave had lunch with the Michauds in the log house. The man and wife confided to Frank Michaud that when they had inquired in Custer about Jewel Cave, businesspeople had told them not to waste their time because it was nothing but a "rat hole in the ground." (Courtesy of the Michaud family.)

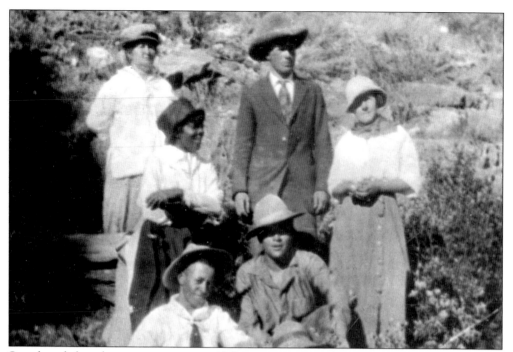

Seen here below the cave entrance is a 1917 tour group. Standing from left to right are Estelle Zering, Vern Morris, and Lillian Morris. Callie Ward is seated on a log, and seated on the ground are Elbert (left) and Harry Ward. (Courtesy of the National Park Service, Jeca 1799.)

In 1928, a group of businessmen from Custer and Newcastle met to discuss Jewel Cave. The USFS had locked the gate to the cave in 1923 and since then had all but forgotten it. Congress had provided little direction or funding for national monuments. The businessmen obtained a permit from the USFS to operate the cave and formed the Jewel Cave Corporation. Charles Perrin, of Custer, was a member of the corporation. (Courtesy of Dorothy Delicate.)

Two

JUST A SMALL CAVE

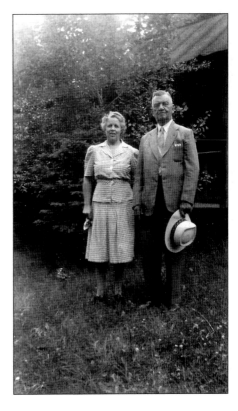

After Mamie Michaud sold her interest in the cave to the Jewel Cave Corporation, the business group constructed stairways, enlarged passages, and improved the road to the cave entrance. They hired three men, including Ira Michaud, to conduct tours. The corporation operated the cave until 1933, when management was transferred from the USFS to the National Park Service. Tom Delicate, seen here with his wife, May, was a Custer businessman and a corporation member. (Courtesy of Dorothy Delicate.)

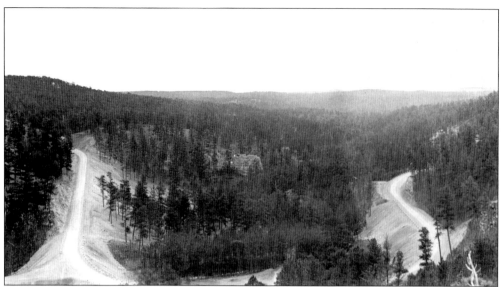

America's love affair with the automobile led to increased road construction in the 1930s and big changes for Jewel Cave. Foreseeing that the cave would attract tourists en route to or from Yellowstone National Park, the Jewel Cave Corporation pushed for a new road between Custer and Newcastle. Highway 16 was completed in 1933. (Courtesy of the National Park Service, Jeca 2896.)

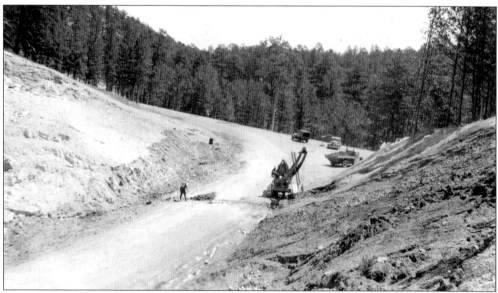

As part of a federally funded project, in 1937 the highway inside the national monument was improved. The entire roadbed was excavated, and unsuitable red clay was replaced with more durable materials to provide better access to the attraction. (Courtesy of the National Park Service, Jeca 2898.)

A vehicle travels west on Highway 16 inside the national monument in this scene from 1937. The cave lies to the south of the highway, which winds through Hell Canyon. (Courtesy of the National Park Service, Jeca 2888.)

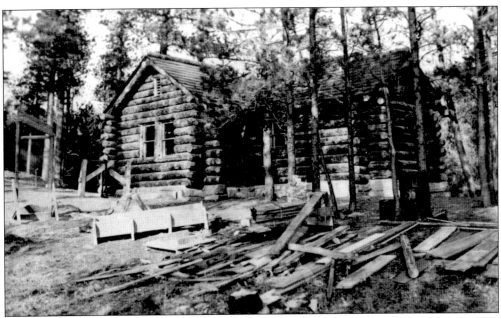

Jewel Cave's metamorphosis from local curiosity to world-class cave received a boost in 1933 with the arrival of the Civilian Conservation Corps (CCC). A small group of CCC enrollees, originally assigned to nearby Wind Cave National Park, set up a "side camp" at Jewel Cave. The first project was building a three-room ranger cabin. (Photograph by Baker; courtesy of the National Park Service, Jeca 2631.)

The cabin, which served as park headquarters, is in the national monument's historic area near the cave entrance. The building, completed in 1935, was placed some 60 years later on the National Register of Historic Places. (Courtesy of the National Park Service, Jeca 2628.)

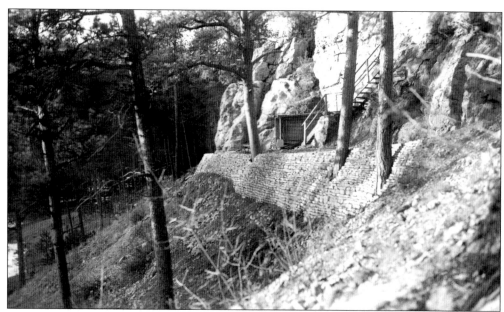

Also in 1935, the CCC built a new path with a stone terraced embankment from the ranger cabin to the cave entrance. The earlier wooden steps seen here were replaced by a trail of stone stairs. The corps men also created trails from the parking lot to the cabin and from the parking lot to the cave entrance, and landscaped and fenced the entire park. (Photograph by Serrano; courtesy of the National Park Service, Jeca 2794.)

When the National Park Service took over management of the national monuments, Jewel Cave became the responsibility of the superintendent of Wind Cave National Park. Temporary seasonal rangers conducted tours and protected the cave. The first permanent ranger, Elwood Wolf (pictured here) was assigned in September 1941. He lived in the ranger cabin. (Courtesy of the National Park Service.)

After the United States entered World War II and for some years to come, few projects were carried out in the parks because no funds were available. This entrance sign, erected in 1942 at Highway 16, was one of the only improvements made at Jewel Cave. (Photograph by Wilkie; courtesy of the National Park Service, Jeca 2636.)

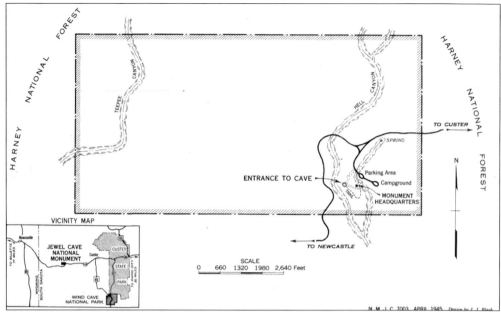

Following the war, Americans flocked to the nation's parks. Visitation at Jewel Cave jumped from 338 in 1945 to 5,943 in 1951. However, park facilities were rustic. Park officials proposed a visitor center and improvements in the cave, but they did not persuade Congress to appropriate the funds. This map of the national monument appeared on the back of its first brochure in 1945. (Courtesy of the National Park Service, Jeca 707.)

The park was open every day from May through September. Tours began hourly from 8:00 a.m. to 4:00 p.m. In this 1946 photograph, Lyle Linch, ranger in charge, stands at the cave entrance. He holds one of the gasoline lanterns used to light the way during trips inside. Linch proudly told visitors that the Jewel Cave tour was the "most rugged trip offered in . . . NPS operated caves." (Courtesy of the National Park Service, Jeca 72.)

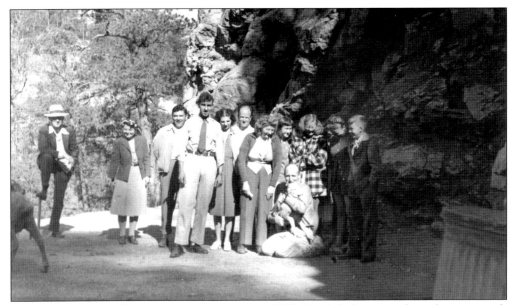

A tour group assembles at the cave entrance in 1947. Linch led visitors through rooms with whimsical names such as Heaven and Purgatory, explaining the origins of the various formations. Having dug his way through blocked passages into unexplored areas, Linch estimated that only about 30 percent of the cave had been discovered. Later he would learn that there was a lot more cave than he had imagined. (Photograph by Lyle Linch; courtesy of the National Park Service, Jeca 74.)

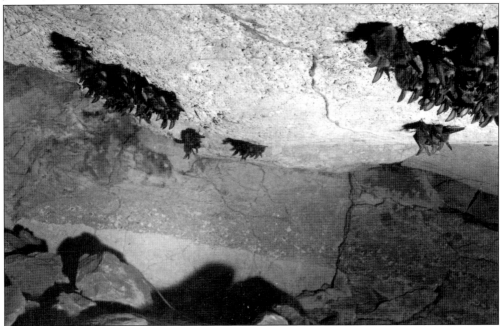

Bats cling to the ceiling of the Catacombs. They are one of the few animals to be found inside the cave. This species, Townsend's big-eared bat (*Corynorhinus townsendii*) hibernates in the cave during the winter. Mice and other small burrowing creatures sometimes are seen near the surface. (Photograph by Dick Hart; courtesy of the National Park Service, Jeca 2116.)

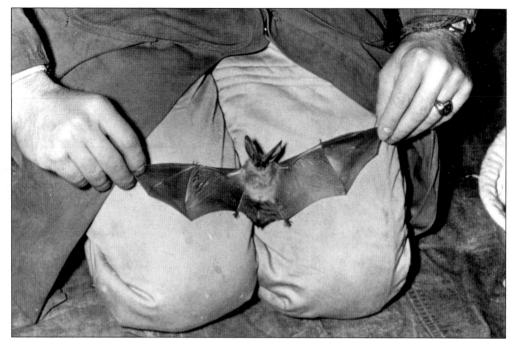

Here is a close-up of *Corynorhinus townsendii*. While it may not be the prettiest of creatures, this bat helps make the world more livable for both man and beast by consuming numerous insects on its nightly forages. (Photograph by John Tyers; courtesy of the National Park Service, Jeca 2124.)

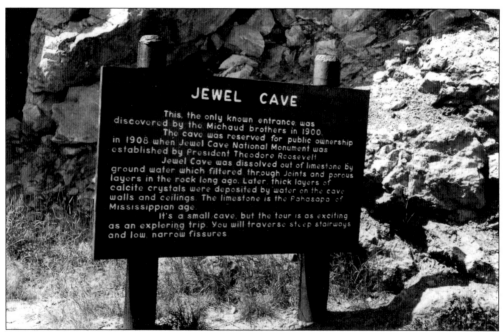

In the 1950s, additional seasonal rangers joined the staff. A one-room wood cabin, moved from Wind Cave National Park, along with a trailer and a bunk in the headquarters building, provided housing. This sign describing Jewel as a "small cave" was another new addition. (Photograph by Dick Hart; courtesy of the National Park Service, Jeca 1990.)

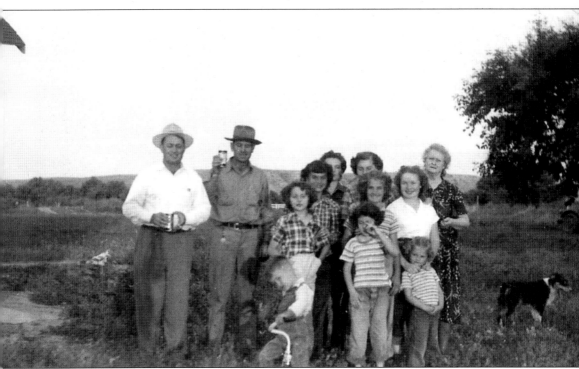

Francis and Ira Michaud frequently took their children to see the cave. Part of the family is seen in this late-1940s photograph taken at Ira's home on Pryor Creek near Billings, Montana. From left to right are (first row) Eileen and Patricia, Francis's daughters; and Renee (Wanda,) Ira's daughter; (second row) Ramona, Delores, and Monica, Ira's daughters; (third row) Francis; Ira; Nettie, Ira's wife; Montaleen, Francis's daughter; and Mamie, mother of Francis and Ira. Francis's son James is in front on a tricycle. Monica Michaud Weldon remembers that her father proudly pointed out the stairs he had helped build. James's brother Michael (not pictured) said that when family members visited the cave in 2004 all agreed that it had lost much of the "sparkle" they remembered as children. Human intrusion causes changes to fragile cave formations. (Courtesy of the Michaud family.)

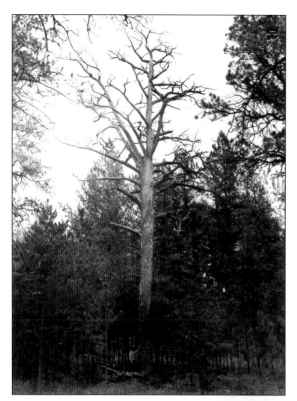

In this 1958 photograph, a ranger stands next to a gigantic dead tree in a stand of ponderosa pine, which dominates the forest in this semiarid region. Other species include shrubs such as snowberry and gooseberry. The National Park Service seeks to preserve the forest above as well as the cave itself. (Photograph by Dick Hart; courtesy of the National Park Service, Jeca 1816.)

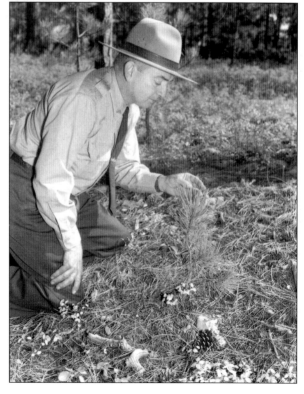

Dick Hart, seen here tending a ponderosa pine sapling, was ranger in charge in the late 1950s. He and his staff used ropes and an aluminum ladder to climb down a deep, dark crevice past Milk River and found four impressive rooms. Later explorers would find leads in these "Discovery Rooms" to discoveries of their own. (Photograph by J. Boucher; courtesy of the National Park Service, Jeca 1832.)

Three

METAMORPHOSIS

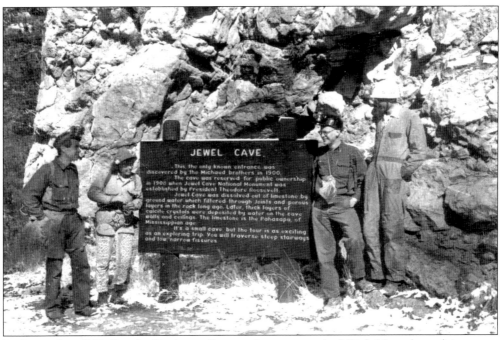

In September 1959, Dwight Deal, a college student, approached Dick Hart about doing some mapping in Jewel Cave. Hart was enthusiastic, but he insisted that Deal find at least two partners. Deal convinced a couple of avid rock climbers he had met, Herb and Jan Conn, to join him. Alongside the sign they soon would make obsolete are (from left to right) Herb and Jan Conn; David Schnute, a Wind Cave ranger; and Dwight Deal. (Photograph by Dwight Deal; courtesy of the National Park Service, Jeca 3354.)

Dwight Deal, now a geologist, caved with the Conns for several months until he left to go to graduate school. By that time, the team had mapped about seven and a half miles. What hooked Herb and Jan Conn, Deal says, is that Jewel Cave is an "intriguing maze. It's up and down, around and through, over and under and in-between." The Conns stand at the historic entrance of the cave. (Photograph by Don Gillespie; courtesy of the National Park Service, Jeca 1946.)

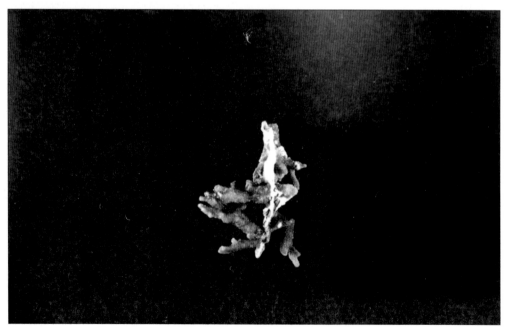

Caving is an intellectual as well as a physical challenge, Deal claims. He earned his master's degree through his research in the cave. One of his studies focused on the scintillite, so far found only in Jewel Cave. (Photograph by Dwight Deal; courtesy of the National Park Service, Jeca 3331.)

Like others who had gone before them, the Conns began their adventure in the cave at Milk River, a muddy area with a pool of water. Jan, who sings and plays both the guitar and flute, composed a song about the spot. It includes the verses, "Oh, it's there I long to wallow as my carbide (lamp) flickers low, and the mud from old Milk River will be with me wherever I go." (Courtesy of David Schnute.)

Herb Conn squirms into a tight place. Discovering wild cave meant finding leads that were overlooked by previous explorers. Spelunkers go in sometimes head first and sometimes feet first, sometimes on their backs and sometimes on their bellies. The sport is not for the claustrophobic. (Courtesy of David Schnute.)

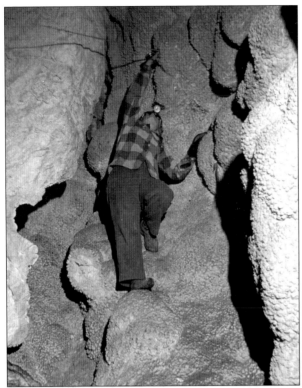

Jan Conn stretches to read the measuring tape at a high survey station. The Conns learned from Dwight Deal how to survey a cave. Usually one team member held a light on a station he had marked, while another used a compass to determine the vertical and horizontal angles and a third person measured the distance between the two locations. They calculated the distances from the stations to the walls, floor, and ceiling. (Courtesy of David Schnute.)

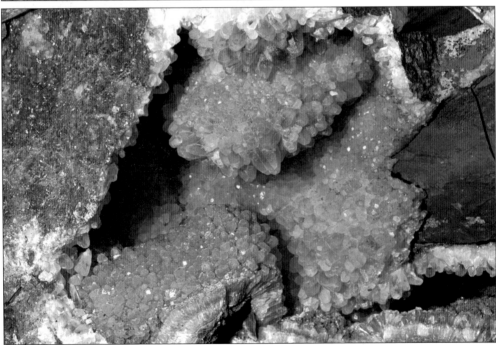

In parts of the cave, the walls are lined with clusters of calcite crystals. Some individual stones are as large as golf balls. The Conns named one stunning room the Crystal Display. (Courtesy of David Schnute.)

The explorers wormed their way through a narrow passage into this big room to the west of the natural entrance. They dubbed it the "Gearbox" because they thought it was shaped somewhat like the shift pattern of an automobile transmission. Herb and Jan remember that David Schnute was first to squeeze though the tight opening into the room. When they inquired whether they should follow, he uttered only, "Holy cow!" It was a phrase he would repeat many times. The trio thought they had found a place where no one else had been, but they were mistaken. "We found this trail of footprints in the earth," Schnute recalls. He followed it for some distance, believing that he would find someone "dead or alive" or another unknown way into the cave. (Courtesy of David Schnute.)

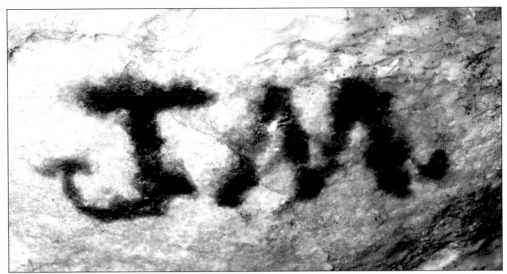

They found smoked onto the ceiling the initials J. M., which they speculated had been left by Joe Michaud. Cave guides occasionally heard from a visitor that he had gone with the Michauds into a huge room that was not on the tour, Schnute said. "The guides would think, 'Yeah, sure.' No one knew of such a room. It had been forgotten, and, apparently, we had found it." (Courtesy of David Schnute.)

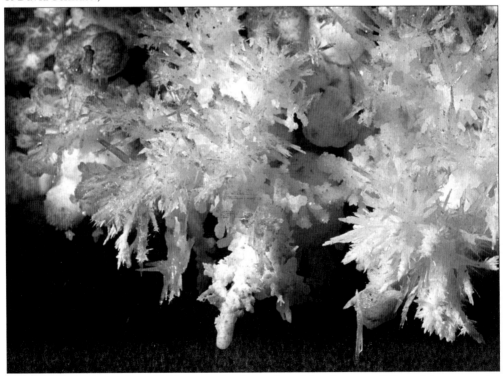

Aragonite in groups of needlelike crystals also is found in the cave. Like calcite, aragonite is made of calcium carbonate, but it crystallizes in a different way. Because the formation sometimes resembles tree branches coated with ice it is referred to as "frostwork." (Courtesy of David Schnute.)

Another speleothem, or cave formation, is boxwork. It occurs when limestone is eroded from between calcite veins in the bedrock, leaving ridges that stand out in relief to form a honeycomb or boxlike pattern. Boxwork also is found in Wind Cave and some other caverns. (Courtesy of Herb and Jan Conn.)

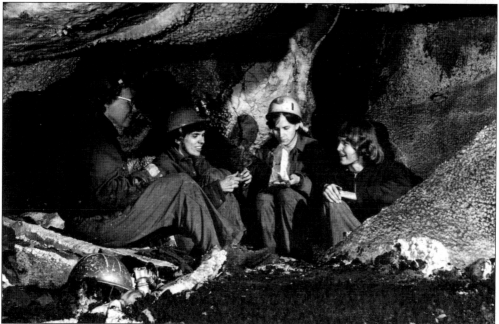

Cavers stop for an underground lunch. From left to right are Jan Conn, Myrna Sheie, Karen Dilts, and Lynn Svatos. Inside the cave, "It's an environment totally different from the surface," Conn says. "When you go back out, it's the outside that seems strange." (Photograph by Larry Dilts; courtesy of Herb and Jan Conn.)

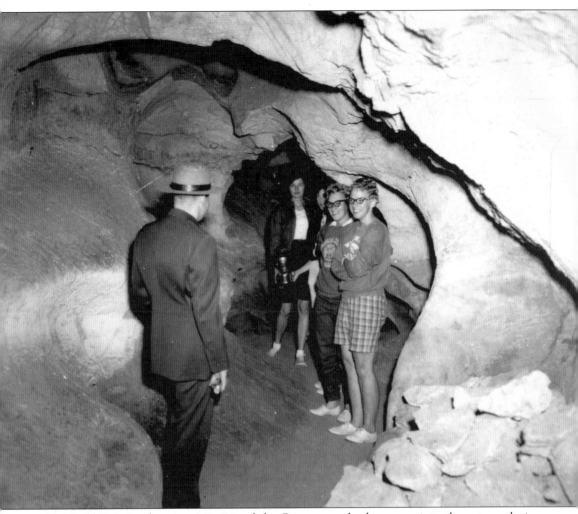

Ranger Al Denny, who sometimes joined the Conn team, leads a group into the catacombs in 1961. Every third person carried a lantern. While the Conns and their cohorts pushed farther into the cave, rangers continued to conduct tours on the established routes. According to ranger Dennis Knuckles, the lanterns would flare and sizzle, and sometimes someone would drop one or accidentally burn the person in front of him. Today paraffin oil lamps are used on the tours, which are conducted from the historic entrance during the summer months. During the winter months, no tours are conducted because bats are hibernating in that part of the cave. (Photograph by John Tyers; courtesy of the National Park Service, Jeca 2076.)

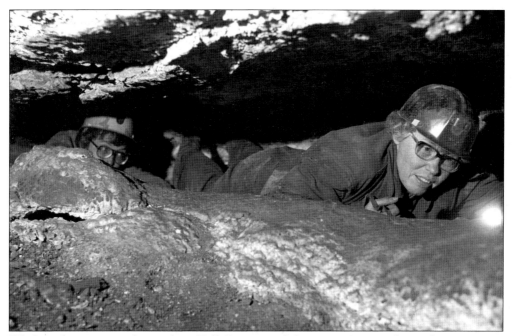

While pushing eastward away from Hell Canyon and the cave entrance, the explorers ran into many dead ends before finding Long Winded Passage, which led them southeastward toward Lithograph Canyon. They employed hammers and crowbars to widen the opening to the passage. Lorene Smedley follows Jan Conn in the crawlway. (Courtesy of David Schnute.)

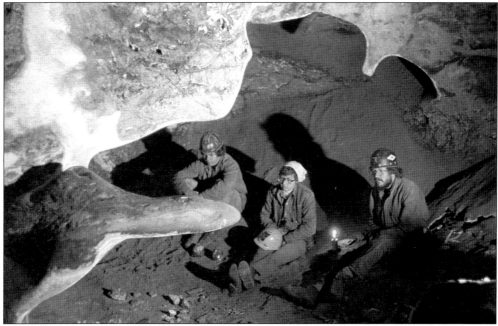

By way of Long Winded Passage, the spelunkers eventually would find the Formation Room, decorated with a large mound of flowstone and stalactites, and other magnificent caverns destined to become highlights of a new tour route. From left to right, Mike Todd, Lorene Smedley, and Mike Spilde take a break in a roomy part of the passage. (Courtesy of David Schnute.)

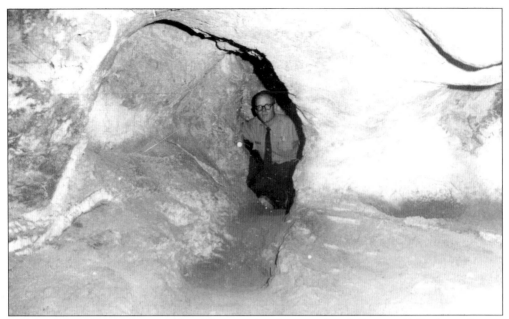

Ranger Pete Robinson (pictured here) became head man at Jewel Cave in 1962. According to the Conns, he encouraged them to scout out new areas. In June of that year, the Conns and Denny climbed up a 30-foot-high chimney into a large cavern that became known as the Target Room. It was to become the site of the new entrance and the beginning of the new scenic tour route. (Photograph by Robert Murphy; courtesy of the National Park Service, Jeca 2234.)

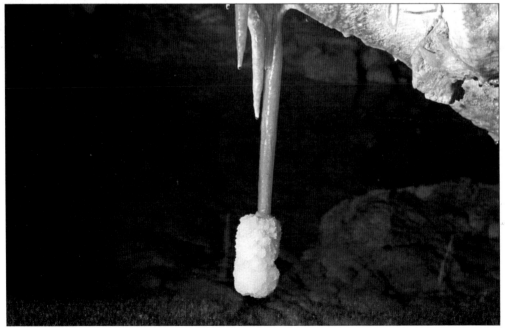

Bottle brushes are a cave oddity found above a pool called Never Never Spring. They are a kind of stalactite with a thick coating of calcite crystals at their tips. Geologists believe that the crystals were deposited when the water level was higher, and the stalactite tips were submerged. (Courtesy of David Schnute.)

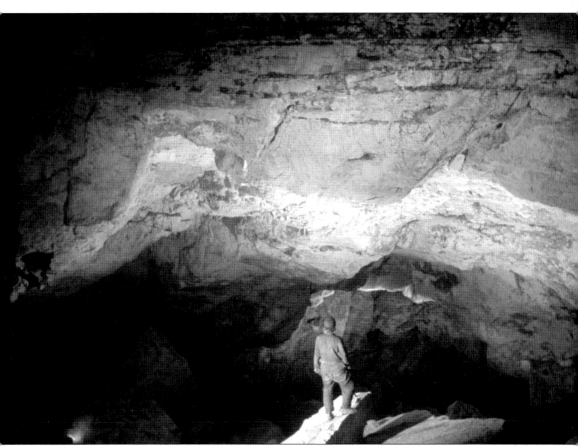

Robinson took to caving enthusiastically and helped remove fallen rocks and clear blocked passages. He frequently provided the explorers with sandwiches and money for gasoline and carbide for their lamps. Along with Robert Murphy, chief ranger of Wind Cave, he made a difficult 11-hour trip with the Conns to see the newly discovered Formation Room. While investigating a lead, Robinson became the first to set foot into what became known as King Kong's Cage (pictured here,) then one of the largest and still one of the most impressive rooms in the cave. According to the Conns, his first look at virgin cave so thrilled him that he spoke about it for weeks afterward. (Courtesy of David Schnute.)

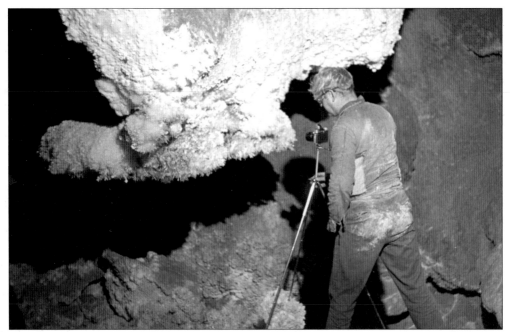

David Schnute took hundreds of photographs inside the cave on his trips with the Conns. He is preparing to photograph frostwork on a formation known as Paul Bunyan's Foot. Jan Conn recalls that Schnute was meticulous in setting his camera and had the patience to take multiple shots to be sure he would get the picture he wanted. (Courtesy of David Schnute.)

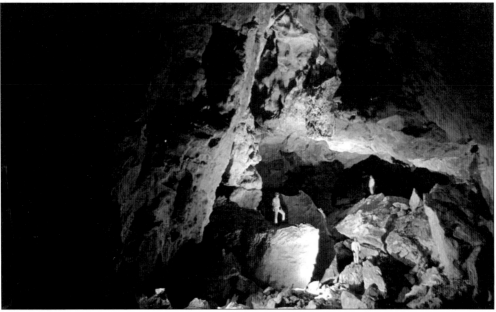

Because there is no natural light in a cave, taking big room pictures like this one was not easy. Schnute first placed his camera on its tripod and opened the shutter. He asked someone to take a flash unit and walk about the room, splashing it with light. Taking care to shade the lens to prevent light streaks, he then closed the shutter. "I never knew what I would get until the film was developed," he says. (Courtesy of David Schnute.)

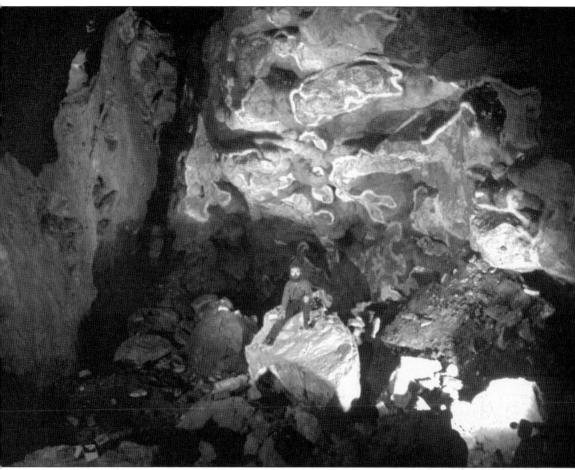

Noel Alexander was a long way from home in this photograph taken in December 1960. Schnute and Jan Conn were on their way to the cave for a photograph shooting session. Conn would have to man the light while Schnute took the pictures, but there was no one to be in the pictures for perspective. Then they spotted a man walking along the highway west of Custer, displaying a sign that read "From Australia." According to Schnute, the duo picked up the hitchhiker and "dragged him into the cave." He adds, "They were some of the best big room pictures I ever took." For his trouble, Alexander received a night's lodging at Schnute's home in Hot Springs. "The next morning, he went on his way. I don't know what happened to him after that," Schnute says. (Courtesy of David Schnute.)

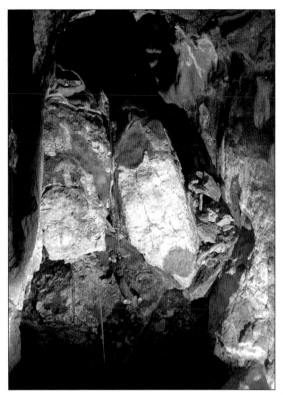

David Schnute remembers asking Jan Conn to pose for a picture while she was rappelling down a cliff. She had to cling to her rope while he adjusted his settings and took picture after picture. "I don't know how she did it," he says. "She must have held her breath or something." (Courtesy of David Schnute.)

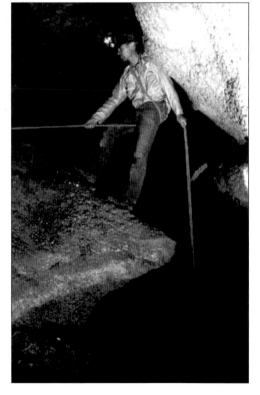

Herb Conn demonstrates a method for roping down a short distance. He has run the rope between his legs, across his chest and over one shoulder, allowing him enough control to slide down easily. The cave has several levels, including the lower and main passages, where the walls are crystal-lined, a layer of siliceous rock known as chert embedded with limestone and the "lofts" at the highest level. (Courtesy of David Schnute.)

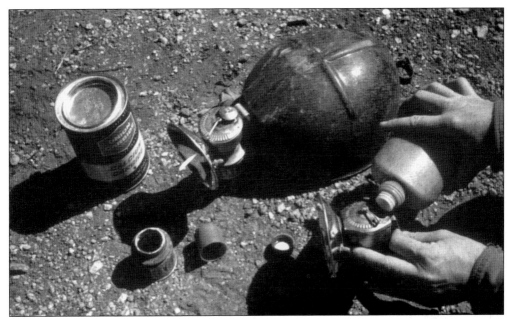

A caver refills a carbide lamp, then his most important piece of equipment. Explorers also carried a flashlight and candles and matches as alternate sources of light. They wore hard hats, sturdy shoes, and gloves but carried little extra clothing because the cave remains at about 46 degrees Fahrenheit year-around. Depending on where in the cave they were headed, they may also have taken knee, elbow, or hip pads; rope; or surveying equipment. (Courtesy of David Schnute.)

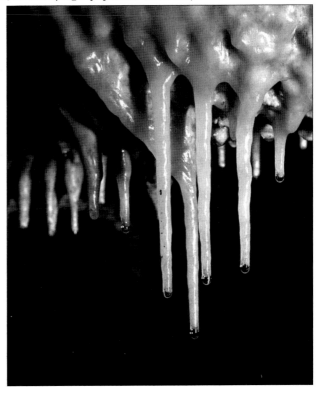

Stalactites may resemble icicles, but they are formed by a buildup of mineral deposits as water from the surface drips slowly into the cave. Early visitors removed or broke these fragile structures in some areas, including Milk River. (Courtesy of David Schnute.)

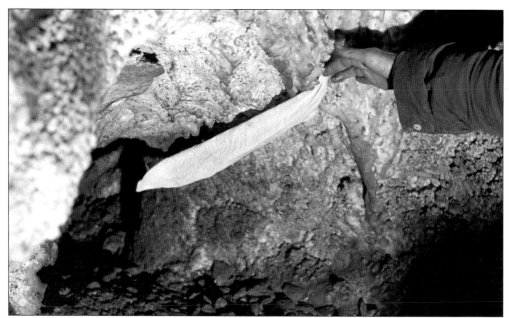

The wind sucks a handkerchief into an opening in Hurricane Corner. In July 1962, while scrambling through some passages near the Target Room, Al Howard, ranger Pat Ryan, and the Conns were buffeted by a furious wind gushing from this little hole. Scientists measure changes in barometric pressure to calculate the volume of caves. A strong wind is a clue to explorers that there is more cave ahead or, sometimes, an entrance. (Courtesy of David Schnute.)

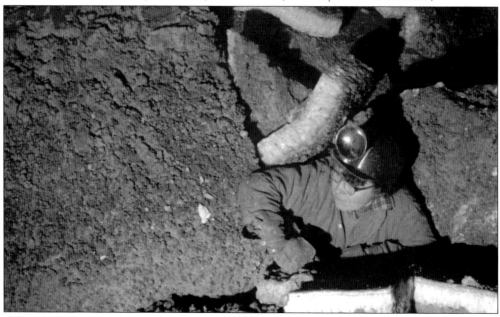

"The wind takes the easiest path through the cave, but it's not always the easiest way for us," Jan Conn complains. It may blow in one direction for a few minutes or for several days before changing course. In parts of the cave the wind defies scientific theories about barometric pressure, and in one spot it always blows in the same direction. "That makes you scratch your head for a while," she says. (Courtesy of David Schnute.)

Mike Spilde enters the Pool Room, one of the caverns just beyond Hurricane Corner. The explorers found large stalactites and a prominent waterline indicating that the room once had contained a pool. (Photography by Larry Dilts; courtesy of Herb and Jan Conn.)

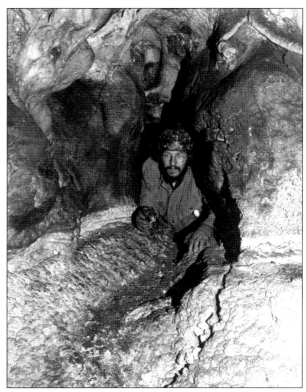

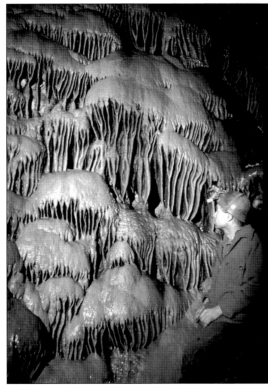

Herb Conn admires the Frozen Waterfall, a 20-foot-high dripstone cascade. Some other caves, including Mammoth Cave, have similar dripstone formations. (Courtesy of David Schnute.)

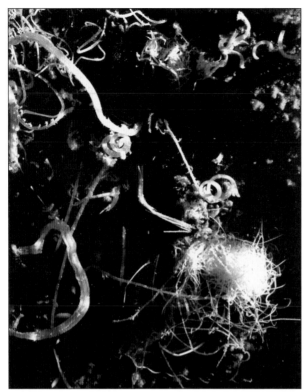

Selenite, or gypsum crystals, are rare but occur in a variety of forms in Jewel Cave. Geologists think the crystals form when gypsum dissolves in the overlying layers of limestone and sandstone. When water seeps into the cave, it evaporates and leaves deposits of gypsum. Sometimes selenite is found in combination with sulfate crystals on the cave walls. Gypsum "flowers" often take on fantastic shapes. To some, they look like wild flowers about to bloom. Gypsum "beards" are clumps of micro-crystal threads so fine and fragile that the slightest wind stirs them. They may grow to a foot long. (Left; courtesy of Herb and Jan Conn; below; courtesy of David Schnute.)

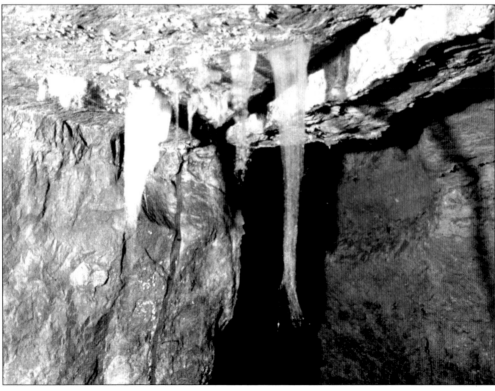

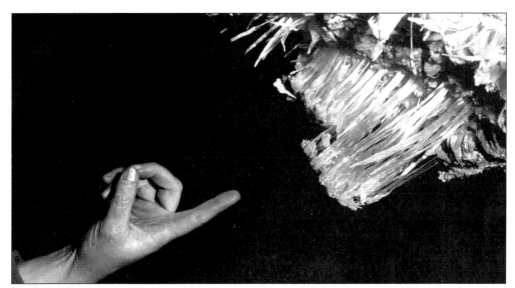

Rarest of all are gypsum "spiders." Like all selenite crystals, they are clear or white in color. Many other cave formations, including dripstone, stalagmites, and stalactites, may be quite colorful, sporting hues of brown, red, or yellow. (Courtesy of David Schnute.)

The Conn team's discoveries led to renewed interest in Jewel Cave. In 1964, U.S. senators George McGovern and Karl Mundt were successful in securing congressional funding to revamp the cave. On June 13, Bob Nichols drilled to a depth of 190 feet and broke into the Target Room. It was the first step toward construction of an elevator shaft, a new tour route, and the long-awaited visitor center. (Photograph by Larry Dilts; courtesy of Herb and Jan Conn.)

Congress authorized $133,000 for new buildings and utilities and $112,500 for road and trail construction. This 1962 photograph depicts the site in Lithograph Canyon of a proposed tunnel to provide workers access to the new tour route. Much of the new cave area lay outside the original boundaries of the national monument in Black Hills National Forest. So that the visitor center and new entrance could be built at the proposed site, Congress in 1965 enacted a land swap between the National Park Service and the USFS. Pres. Lyndon Johnson signed the bill on October 9. Only about 11 percent of the original monument remained inside the redrawn boundaries. (Photograph by John Tyers; courtesy of the National Park Service, Jeca 1972.)

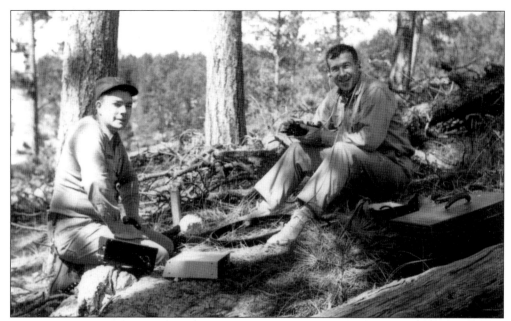

In 1965, the National Park Service hired two hard-rock miners, Everett Chord and Ray Bettenhouse, to dig a vertical shaft four feet wide into the side of Lithograph Canyon where a crawlway near the Target Room came near the surface. Here two men may be seen above the cave using surface-to-cave radios to verify an underground location. (Courtesy of the National Park Service, Jeca 2657.)

When the shaft was finished, engineers and other workers entered the cave to make plans for the elevator that would take tourists down to the new cave routes. In this photograph from November 1966, a construction crew works on the elevator shaft collar. (Photograph by Don Gillespie; courtesy of the National Park Service, Jeca 2702.)

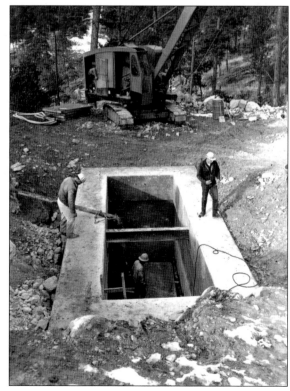

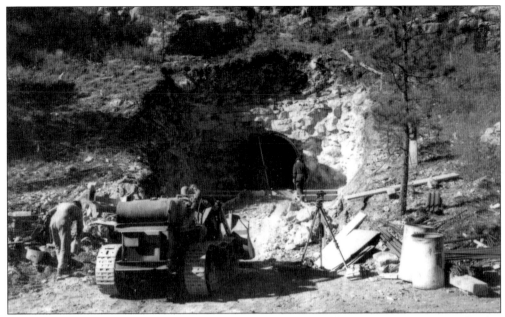

The need for a new tour route became evident in the early 1960s. The park received some 45,000 visitors in 1963, and the following year people often had to be turned away because the tours were filled. This 1966 photograph shows construction workers leveling and clearing the ground in front of the access tunnel. (Photograph by Don Gillespie; courtesy of the National Park Service, Jeca 2180.)

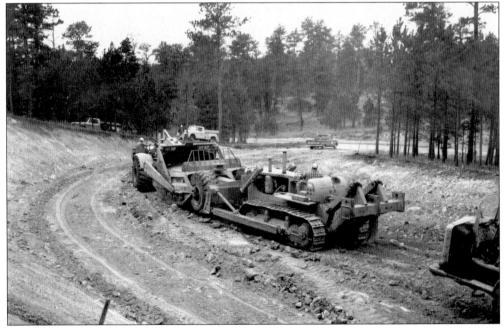

Work on the new visitor center and administrative complex began in 1965 and continued for the next seven years. Contracts were awarded for the various construction projects. Here the entrance road takes shape. (Photograph by John Tyers; courtesy of the National Park Service, Jeca 2690.)

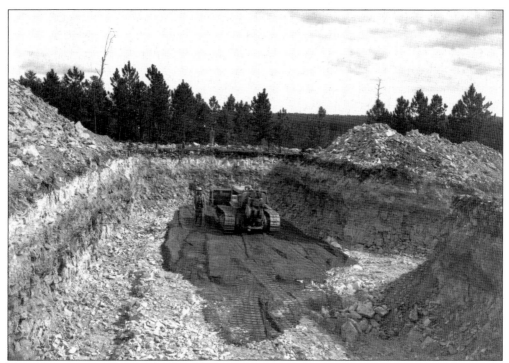

Another project was the building of a 100,000-gallon underground reservoir to provide water for the new area. It is located on the hill above the headquarters building. (Photograph by John Tyers; courtesy of the National Park Service, Jeca 2190.)

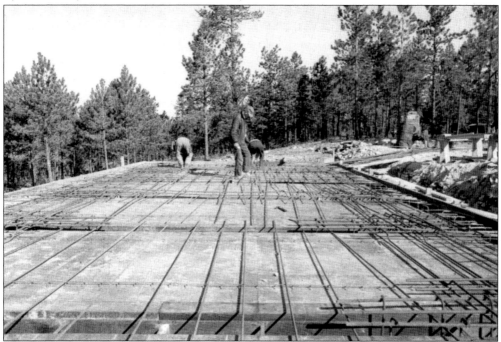

By spring of 1966, workers were reinforcing the roof of the concrete reservoir. (Photograph by Look; courtesy of the National Park Service, Jeca 2852.)

The retaining wall along the parking area at the west end of the complex was completed in 1966. The new facilities would relieve traffic at the original entrance so that the park could better manage it as a historic area. (Photograph by Don Gillespie; courtesy of the National Park Service, Jeca 1928.)

The headframe was placed over the elevator shaft in March 1967. A kind of stationary crane, the device made it possible for workers to bring rocks and dirt to the surface and lower tools, concrete, and other construction materials to the work area. (Photograph by Don Gillespie; courtesy of the National Park Service, Jeca 2450.)

Inside the 280-foot-deep elevator shaft, the contractor's crew prepares the form so that concrete could be poured for the walls. Later a small gable-roof structure was built in the Target Room to provide protection from rocks falling from the ceiling. (Photograph by Don Bottles; courtesy of the National Park Service, Jeca 3021.)

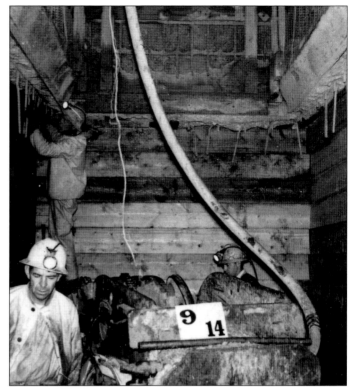

Work also began on the new tour route. One of the first projects was construction of this temporary staircase from the end of the access tunnel to the Target Room, where the tours would begin. This wooden structure later would be removed. (Photograph by Don Gillespie; courtesy of the National Park Service, Jeca 2394.)

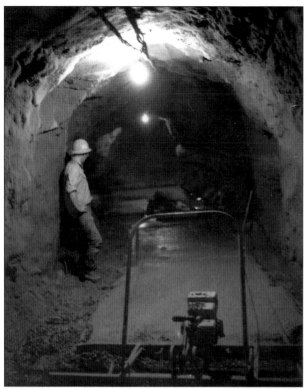

Inside the access tunnel, workers pour concrete so that vehicles may be driven inside. The device in the foreground, called a screed, smooths the concrete to make sure it is applied evenly. Tunnels connecting the elevator shaft to the Target Room also were built. (Photograph by Don Gillespie; courtesy of the National Park Service, Jeca 2162.)

The portal and tunnel complete, electric power and lighting were installed in July 1967. A construction worker moves heavy-duty electric cable into the tunnel. Electric lights along the tour route were concealed. (Photograph by Don Gillespie; courtesy of the National Park Service, Jeca 2166.)

Upgrading the park also included landscaping. Here workers place straw over grass seed planted along the roadside in the ranger quarters area. Later ornamental shrubbery would be planted around buildings. (Photograph by Don Gillespie; courtesy of the National Park Service, Jeca 1872.)

Cave employees in January 1968 worked on a long staircase that served as an emergency route. It extended from the lower to the upper level of the Target Room, bypassing the elevator shaft. (Photograph by Don Gillespie; courtesy of the National Park Service, Jeca 2416.)

Wes Hansen, in charge of trail-building, examines the site where his crew would place a stairway in the Target Room in February 1968. According to Herb Conn, before work on the stairs and trails could be started, the crew had to remove some huge boulders that blocked the way, using only tools that could be carried in by hand. (Photograph by Don Gillespie; courtesy of the National Park Service, Jeca 3248.)

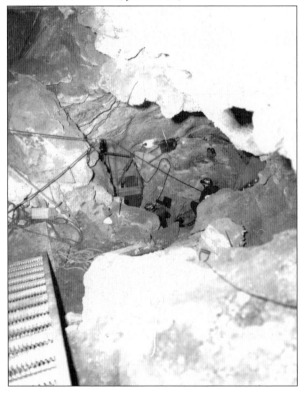

Vehicles could not be used on the tour route, so concrete for the trails was carried in by hand. Don Lytle, then a seasonal worker at Jewel Cave, says crew members filled automobile tire inner tubes with concrete, slung the tubes, each weighing about 60 pounds, over their shoulders, and carried them one at a time into the cave. "We made many, many trips," he adds. (Photograph by Don Gillespie; courtesy of the National Park Service, Jeca 2502.)

A worker uses a "whacker" to compress and settle the asphalt on the trail leading up to the first stairway on the scenic route. On other cave trails, asphalt was replaced with concrete to avoid potential contamination of the cave interior and provide a safer walking surface. (Courtesy of the National Park Service, Jeca 3107.)

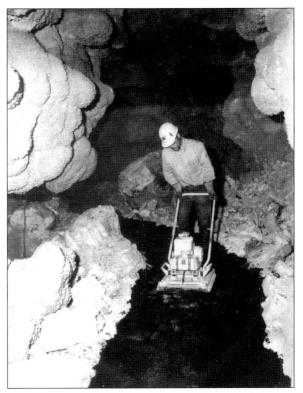

The trail shop in Lithograph Canyon housed the generator and contained a work area. The staircases were prefabricated in the workshop and carried into the cave where they were assembled. (Photograph by Don Gillespie; courtesy of the National Park Service, Jeca 2294.)

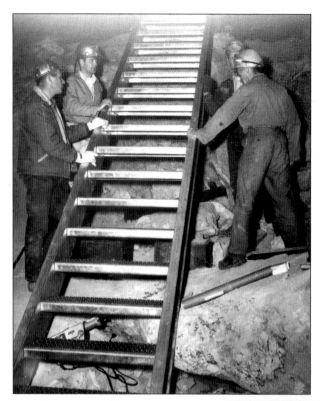

The first stairway is set into place in the Target Room. From left to right are Wes Hansen, Keith Felbaum, Ray Hespin (partly obscured), and Herb Conn. Conn worked on the stairways because exploration was halted during construction. (Photograph by Don Gillespie; courtesy of the National Park Service, Jeca 2442.)

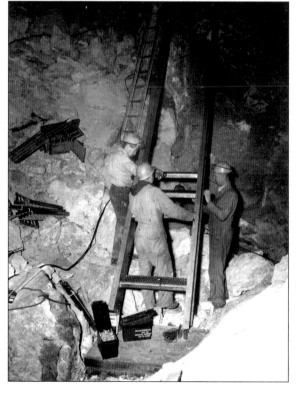

Preparing to bolt rungs onto a ladder are (from left to right) Herb Conn, unidentified, and Don Lytle. "We did something different almost every day," Lytle recalls. "There were challenges every day, but we knew what we'd done would be there for a long time." (Photograph by Don Gillespie; courtesy of the National Park Service, Jeca 2474.)

By April 1968, work on the first three staircases was almost complete. More than 50 stairways and bridges were built. (Photograph by Don Gillespie; courtesy of the National Park Service, Jeca 2446.)

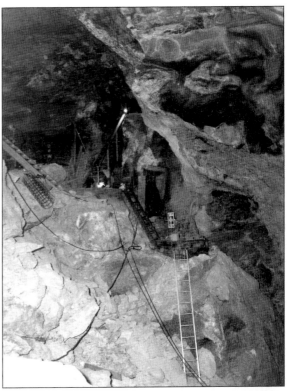

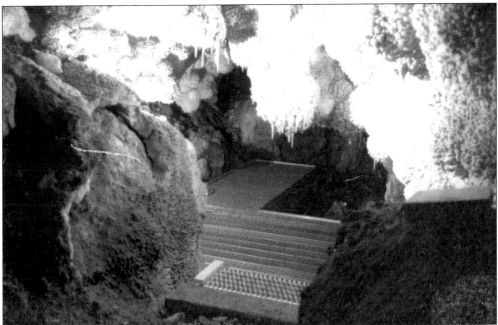

The viewing platform in the Formation Room was well underway in December 1968. Handrails would be added next. With lovely crystal walls, as well as draperies, cave bacon, and stalactites, the Formation Room is one of the most popular stops on the tour route. (Photograph by Don Gillespie; courtesy of the National Park Service, Jeca 2536.)

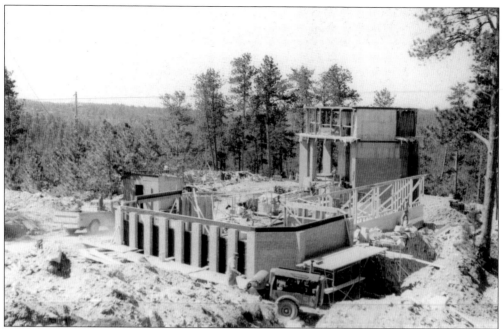

In November 1970, the Corner Construction Company of Rapid City moved into the park, and excavation for the visitor center basement and of the area around the elevator shaft began. The crew graded the site, drilled holes for piers, set forms, and poured concrete. In the foreground, the restroom building is going up. (Courtesy of the National Park Service, Jeca 2988.)

The hexagon-shaped structure is the beginning of the exhibit room. In addition to displays on cave exploring, it has seating and a screen for lectures. One wall is covered by a map of the cave. The visitor center also houses a book store, an information desk, and an assembly area for the tours. (Courtesy of the National Park Service, Jeca 2970.)

The historic area also saw improvements. In 1962, a well and pump house, along with a pipeline connecting the well to the CCC-built reservoir, were completed. Water to the campground had been turned off the previous year because the dwindling supply could no longer meet the demand. (Photograph by Pete Robinson; courtesy of the National Park Service, Jeca 2058.)

In 1966, work began on the right-of-way for a power line for the new pump. This view is to the northwest with the entrance road in the foreground. A septic tank and filter field were built to handle sewage from the temporary headquarters. (Photograph by Don Gillespie; courtesy of the National Park Service, Jeca 1848.)

Additional parking spaces were constructed, the trail to the cave entrance was resurfaced, and handrails were installed. This ticket kiosk was brought from Wind Cave and installed in front of the ranger cabin to handle the crowds of visitors. (Photograph by Don Gillespie; courtesy of the National Park Service, Jeca 1908.)

These trailers served as ranger quarters in the historic area in the 1960s. Later they were replaced by a four-unit apartment complex in the new area. All structures, except the ranger cabin and the pump house, were removed from the historic area in 1982. (Photograph by Don Gillespie; courtesy of the National Park Service, Jeca 1884.)

Another trailer served as the temporary park headquarters. It housed an office and restrooms. The park's new administrative building is near the visitor center. (Photograph by Don Gillespie; courtesy of the National Park Service, Jeca 2266.)

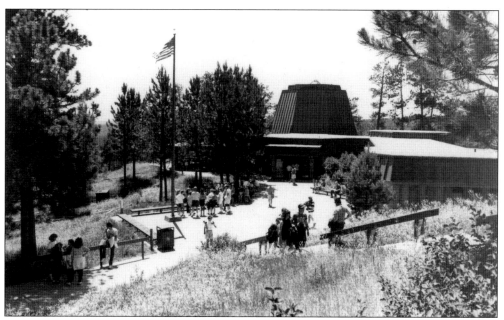

Most of the work on the $1.9 million visitor center was completed by March 1972. Then sidewalks were built, handrails were added to the steps, an outdoor drinking fountain and benches were installed, topsoil was spread, and a flagpole was erected near the main entrance. A dedication and ribbon-cutting ceremony took place on May 28, 1972. (Courtesy of the National Park Service, Jeca 2665.)

Because the national monument was heavily forested, tree removal was a major undertaking for the new construction projects. Both old and new methods were employed. Logging trucks were used to haul these large trees from Hell Canyon, while mule skidders, like this one hauling a log along the power line right-of-way, worked in the rough and rugged areas. In 2000, the Jasper fire would destroy about half the trees in the monument. Pest and nonnative plant species spread in areas that had been denuded. Restoring the damaged ponderosa pine ecosystem is an ongoing process. (Above, photograph by Don Gillespie; courtesy of the National Park Service, Jeca 2222; below, photograph by Don Gillespie; courtesy of the National Park Service, Jeca 2218.)

What looks like cave art with a modernistic touch actually is the work of bats. The marks are left by the animals clawing the ceiling of the cave while seeking a place to roost. A dozen species of bats may be found in the park. (Courtesy of David Schnute.)

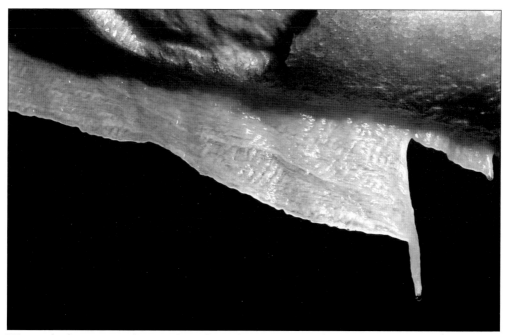

Water, which seeps into the cave from the surface, creates a wide variety of stalactites, stalagmites, and dripstone formations. The water picks up limestone on its way through the cracks in the rock and leaves deposits of travertine, a calcite precipitate, as it drips from the ceiling. This banded ribbonlike structure is called cave bacon. (Courtesy of David Schnute.)

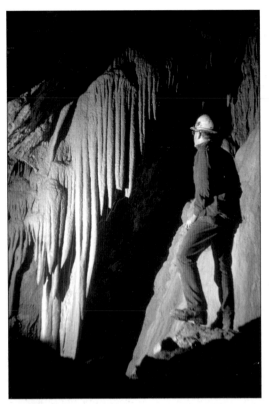

Dripstone formations include draperies, which can be massive and sometimes multicolored. David Schnute stands on a rock to get a closer look. A cave guide at Wind Cave National Park, Schnute had done a little exploring in Jewel Cave when he met the Conns on Halloween 1960. He caved with them until 1968, when he took a job at another park. "They still are some of my closest friends," he says. (Courtesy of David Schnute.)

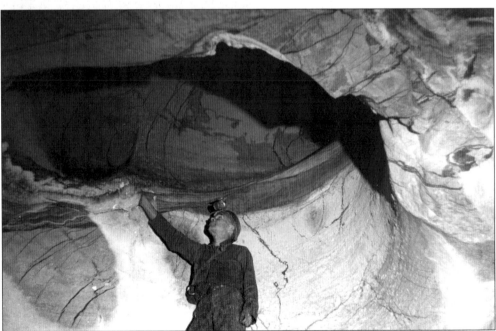

Lofts are the high points in the cave. Typically they have a dome-shaped ceiling, as Herb Conn points out in this photograph. The powdery limestone walls often contain fossils of brachiopods and other ancient sea life. Some lofts have lovely frostwork. (Courtesy of David Schnute.)

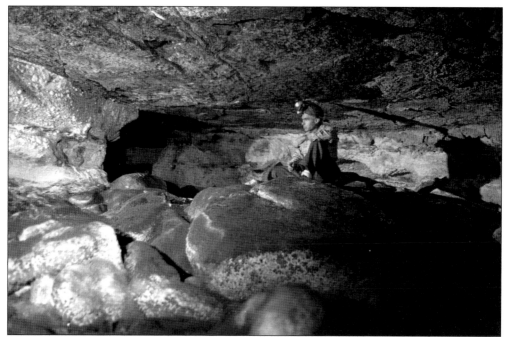

Herb rests after a long climb. Reaching a loft is "an end in itself," he wrote in the *Jewel Cave Adventure*, a book he coauthored with Jan. It "provides a climax, like (scaling) the summit of a mountain." (Courtesy of David Schnute.)

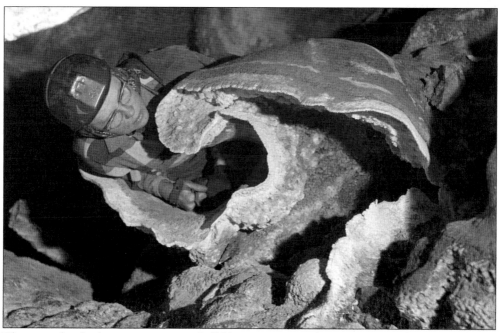

The upper levels also contain vents, shell-like structures with an opening and a smooth calcite rim. The rims sometimes are shaped in a graceful swirl like a frozen wave. Vents are thought to have been formed by water currents when the cave was submerged. Here Jan Conn peers into a large vent known as "the Ear." (Courtesy of David Schnute.)

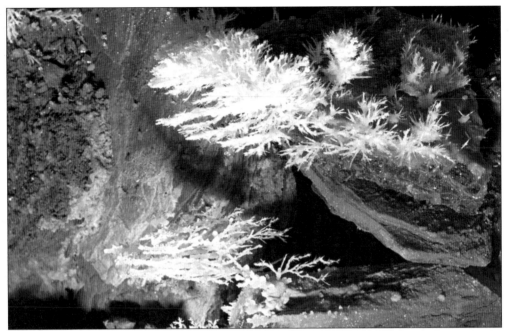

In a place called Shady Acres, Herb and Jan Conn found clusters of translucent calcite crystals. Because the delicate, tiny speleothems reminded them of frosted bonsai trees, they named the spot Japanese Gardens. Even very small cave formations may be beautiful. (Courtesy of David Schnute.)

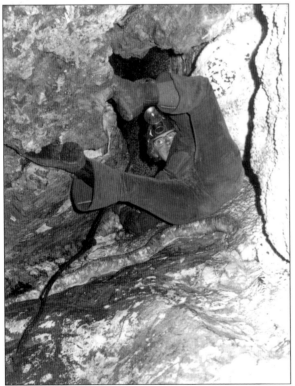

Jan Conn crawls up a vertical chimney to an upper level of cave. Caving can be risky. "It's a lot like rock-climbing," Conn says, "but you can't see where you are going." Once she was working her way up a crystal-coated chimney when the slab on which one foot rested suddenly began to fracture. She told Herb, who was below, to get out of the way because "something was going to come down, me or the rock." She managed to scramble up unscathed. (Courtesy of the National Park Service, Jeca 2996.)

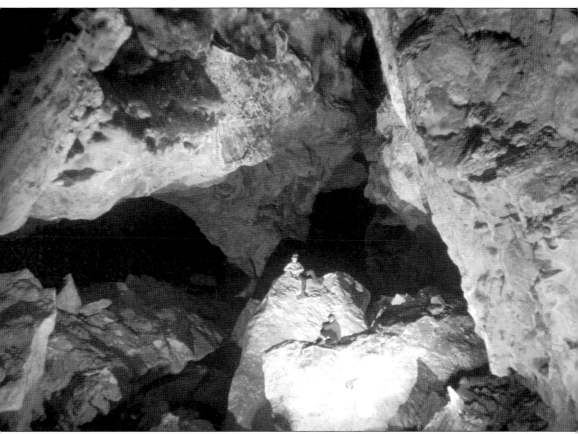

The 3,200-foot-long Corrigan Passage, which is north of the Target Room and runs northeast to southwest, is the longest continuous passage that the Conns discovered. It includes some strenuous climbs and narrow bottlenecks. In some places, huge mounds of fallen boulders make climbing risky. Herb and Jan rest on two of the large boulders that obstruct the passage. The room got its name because they felt that the wind, like the famous aviator Douglas "Wrong Way" Corrigan, seemed to be going in the wrong direction. Corrigan was a Texas aviator who in 1938 was supposed to fly from Brooklyn, New York, to Long Beach, California, but landed in Ireland. He blamed the unauthorized flight on a navigational error. (Courtesy of David Schnute.)

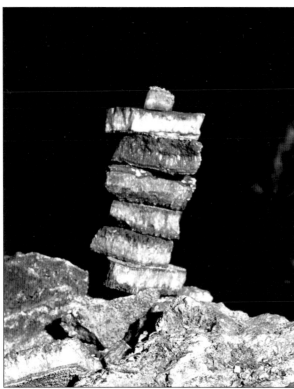

Although sometimes obstacles, fallen rocks have their uses. The explorers used slabs of crystal that broke off the cave walls to make this trail marker. (Courtesy of David Schnute.)

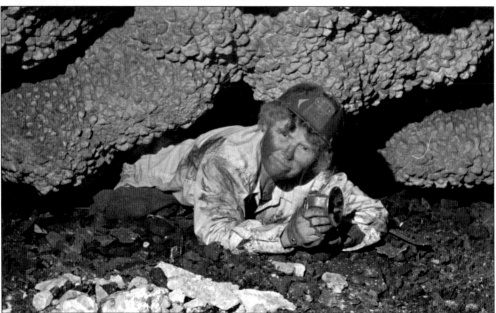

Jan Conn needs no words to explain why sporting goods stores do not carry expensive, designer caving outfits. Spelunking is rough on clothes and skin. Many of the crawlways in Jewel Cave contain manganese dioxide, a powdery black mineral. When it becomes wet, as it often does in the humid parts of the cave, it becomes sticky. It is difficult to wash off, she says. (Courtesy of David Schnute.)

72

The Conn team in 1962 discovered a speleothem new to cave science. Cave "balloons" are lustrous, white, hollow structures composed of a rare mineral known as hydromagnesite. Extremely fragile with a shell about 1/1,000 of an inch thick and only about two inches in length, they grow on the walls in some parts of the cave. Some are as smooth and shapely as handblown glass Christmas tree ornaments. Others appear wrinkled and bumpy like bags of garbage ready to be thrown in the trash. Hydromagnesite balloons also have been found in other caves, including Lechuguilla, located within Carlsbad Caverns National Park, New Mexico. How the balloons form still is unknown. (Courtesy of David Schnute.)

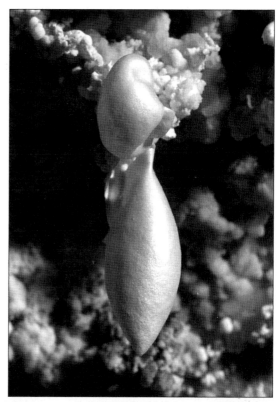

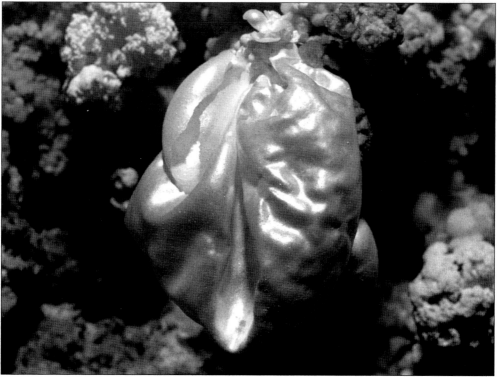

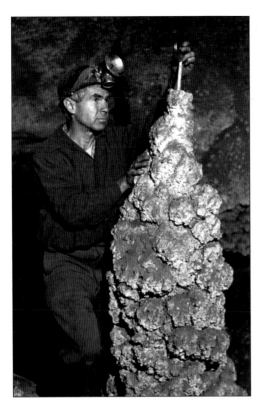

Herb Conn measures the depth of a hollow popcorn stalagmite, or logomite. Like most stalagmites, they are made of calcite, but they have a bumpy texture. The vertical hole sometimes extends well below the base of the stalagmite. Not all popcorn stalagmites are hollow. They are common in Jewel Cave. (Courtesy of David Schnute.)

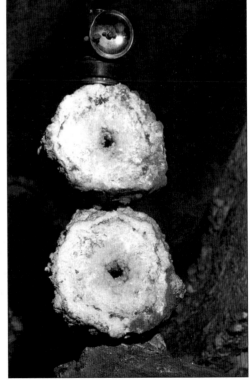

Cross-sections of a broken logomite reveal the center opening. A carbide lamp sits on top for perspective. Stalagmites grow upward from the floor, while stalactites hang from the ceiling. A stalagmite that has fallen is referred to as a snurd. (Courtesy of David Schnute.)

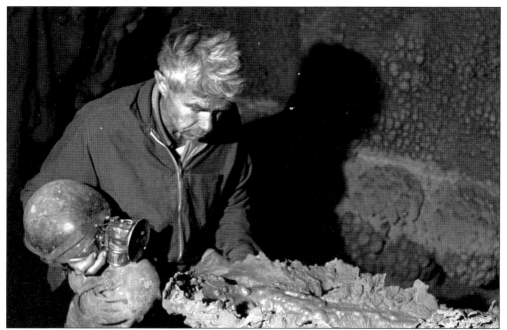

Other cave oddities are found in a large room the team dubbed Hell's Half Acre, because it lies directly under Hell Canyon. Herb Conn examines a conulite, a bowl-shaped calcite formation. Because water sometimes fills the bowl, the formation also is known as a "bird bath." (Courtesy of David Schnute.)

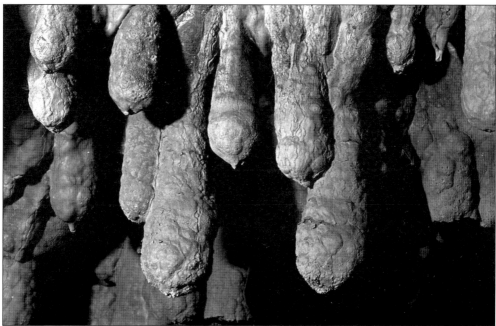

Hell's Half Acre also is home to "billy clubs." They are a kind of stalactite sometimes coated with cave popcorn. Geologists believe that, like bottle brushes, billy clubs were formed when partly submerged in water. Their heavy coating may be the result of muddy water. (Courtesy of David Schnute.)

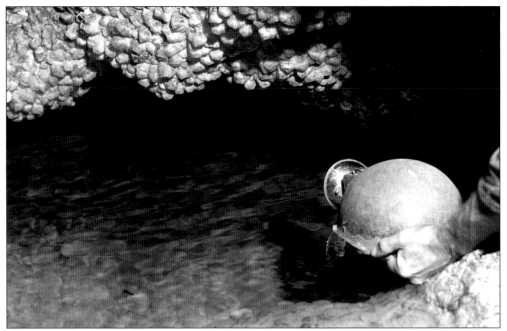

A caver uses the lamp of his helmet to illuminate the pool at a place called High Water. Such pools are a blessing to thirsty explorers, but sometimes they pose a hazard. When the water level rises the pool can block a passage. Explorers use a hose to siphon water from the pool to another spot on the floor so that they can pass. (Courtesy of David Schnute.)

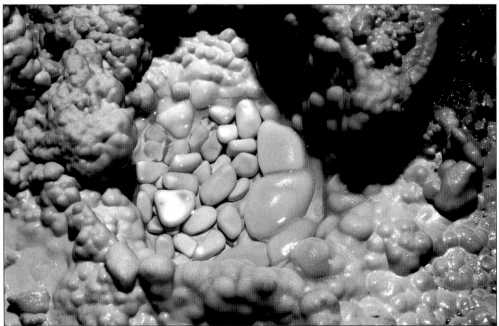

Pools sometimes contain pockets of highly polished white pebbles, commonly called cave pearls. They may be round, cylindrical, or cubical and vary in size from as small as a grain of sand to as large as a Ping-Pong ball. They are found where the water dripping into the pool precipitates calcite. The "pearls" form around tiny fragments of rock in the water. (Courtesy of David Schnute.)

Four

IT GOES AND GOES

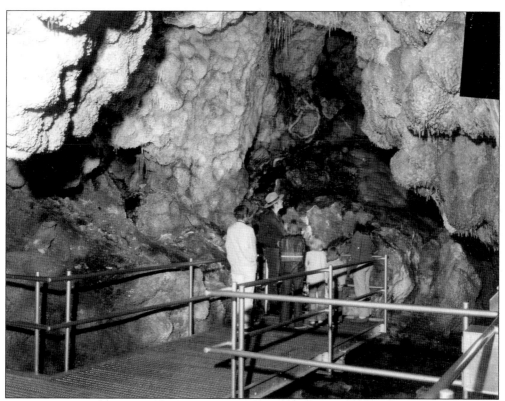

Within a few days after the dedication of the visitor center, rangers conducted eight tours daily on the new route. Dennis Knuckles came to Jewel Cave from California in 1970 and became a park aide. The following year, he became a ranger. Knuckles was instrumental in designing Jewel Cave's spelunking tours, which began in 1974. In this photograph, he guides visitors in the Formation Room. (Photograph by Tom Bean; courtesy of the National Park Service, Jeca 2152.)

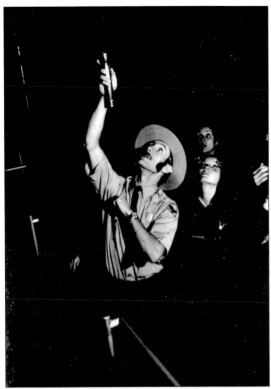

Dennis Knuckles was with the Conns when the explorers reached the 50-mile mark underground. "I took off one of my shoe laces, which were red, and we stretched it across the passage. Then we used a carbide lamp to burn through it in a kind of ribbon-cutting ceremony," he recalls. Here he leads visitors in Rum Runner's Lane between the Formation Room and the Target Room. (Photograph by Larry Dilts; courtesy of the National Park Service, Jeca 2942.)

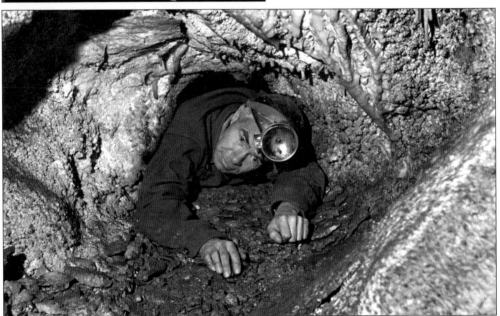

In the early 1970s, the Conn team explored several long and tight passages to the southeast of the scenic tour route. The cavers wriggled on their stomachs some 1,800 feet through the Miseries and the Mini-miseries. Herb Conn says that in the latter passage, he propelled himself forward with his elbows and toes while his buttons popped and his clothing ripped. (Courtesy of David Schnute.)

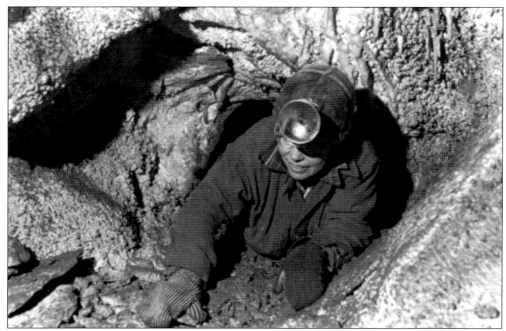

The strenuous trips inspired Jan Conn to write a song, which includes the lines, "Oh, it's a long, long crawlway, who knows where it will end? Now I've struggled to the corner, I can peek around the bend to see a long, long, crawlway." (Courtesy of David Schnute.)

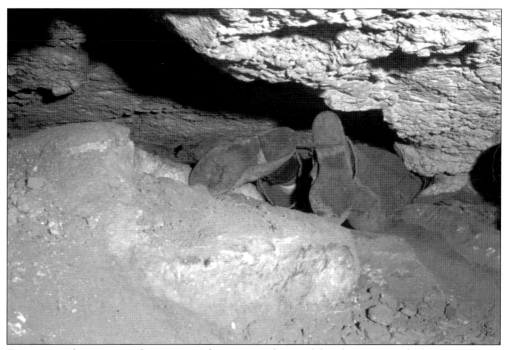

Every sport has its own language with terms understood by the initiates but an enigma to outsiders. It may be difficult to converse while in a crawlway, but when a caver finds a new lead into virgin cave he need only shout, "It goes!" (Courtesy of David Schnute.)

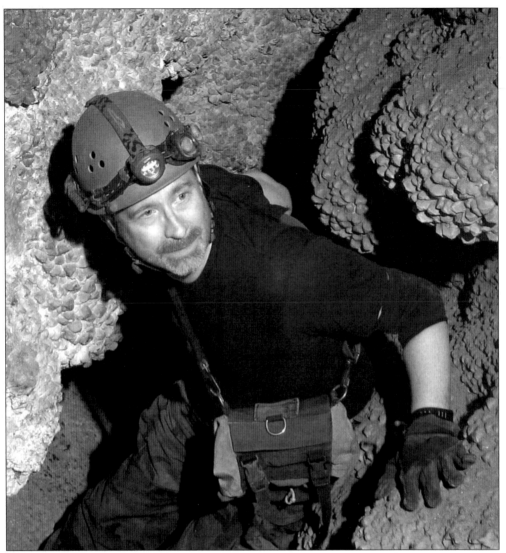

Mike Wiles was a chemical engineering student at the South Dakota School of Mines in the late 1970s when some of his fellow students invited him to join a caving club. Having seen his friends come back from their cave trips in badly soiled clothes, Wiles felt no desire to join them, but he attended a slide presentation on Jewel Cave given by Jan Conn. Following the slides, Conn played her own musical composition, the "Underground Suite." "The cave pictures and the hauntingly beautiful music literally stole my heart," Wiles relates. He wrote the Conns asking if he could cave with them. "I thought there was no way they ever would go with me," he says, "but they wrote back and said they would give me a chance." (Courtesy of Mike Wiles.)

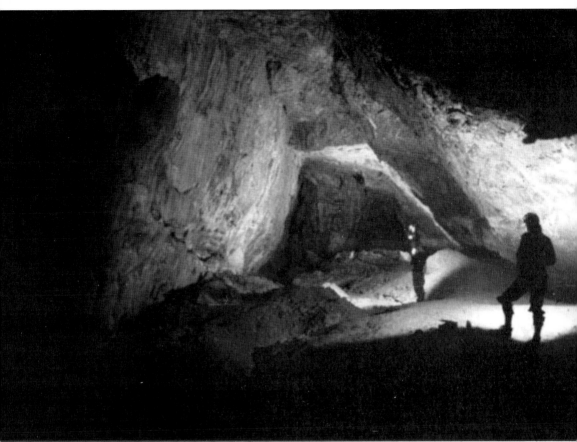

Wiles made many trips with the Conns, beginning in 1977. One of the first involved the VISC (Very Important Short Cut) project. "There was a 30-foot non-connection between Hell's Half Acre and another room called the Other Half Acre. Air would go through, but it was too small for a person to get in. Getting around those 30 feet by another route meant making a six-hour round trip through some very difficult passages," Wiles explains. The team widened the passageway, making it possible for the explorers to spend more time in virgin cave. Wiles, who lives in Newcastle, worked as a Jewel Cave seasonal employee for a while. Later he went back to school and earned a master's degree in geological engineering. In 1997, he became the national monument's cave management specialist. This photograph was taken in Hell's Half Acre. (Courtesy of Marc Ohms.)

Mike Wiles is working on a map that depicts all explored and surveyed passages of the cave. Since the cave continues to grow, it is a never-ending task. He once told Jan Conn that he wanted to do 20 years or 20 miles of exploration in the cave, whichever came first. Later, when he had passed the 20-mile mark, Conn reminded him of his pledge. Wiles quipped, "My replacement hasn't yet been born." (Courtesy of Mike Wiles.)

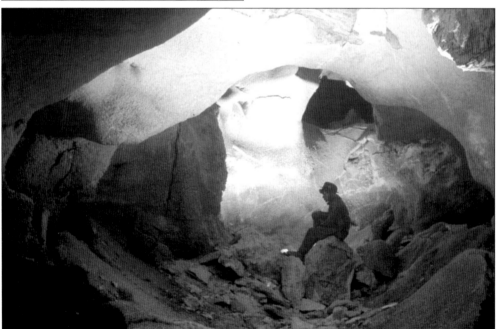

After they discovered and mapped some 64 miles of cave, age forced Herb and Jan Conn to cut back their trips, and Wiles became the chief explorer. "We thought it was important to find someone to take over," Jan said, "Because we didn't want the exploring to stop." (Courtesy of David Schnute.)

In the *Jewel Cave Adventure*, Herb Conn wrote, "As we get older the cave gets tougher, we do not know how many more miles we are good for. But the cave is there. . . . Like the Michauds 70 years ago, we know that we are still just standing on the threshold." (Courtesy of David Schnute.)

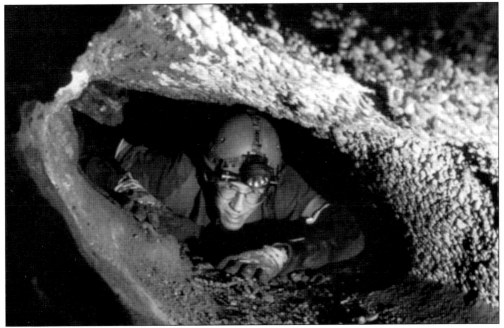

Although a few shortcuts have been found, the new generation of explorers still has to maneuver through the tortuous Miseries to reach new cave. Noah Daniels, a cave management intern, is seen here emerging from the Dugway, at one end of the crawlway, in 1997. (Courtesy of Marc Ohms.)

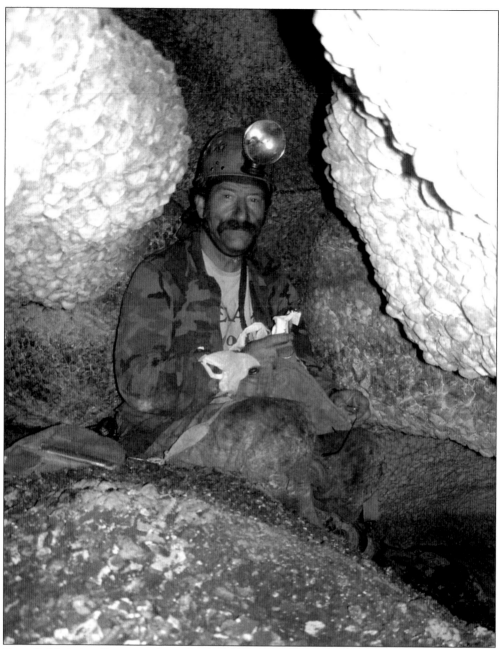

Steve Baldwin is a Custer resident who explored about 30 small Black Hills caves before joining Mike Wiles in Jewel Cave. He was with Wiles and Ken Allgier, another Jewel Cave employee, in May 1987 when the team found a "miserable little hole" beyond the Mind Blower where the Conns had ended their mapping. Wiles "tugged, squeezed and pushed" until he got down into the hole, and then he disappeared for about 20 minutes, Baldwin remembers. Like Howard Carter when he first peered into King Tut's tomb, Wiles could not stop talking about the wonderful things he had seen, huge passages one could drive a truck through. "We knew we had found something. It was the beginning of a new era of exploration," Wiles adds. The discovery has led to another 55 miles of cave so far. (Courtesy of Mike Wiles.)

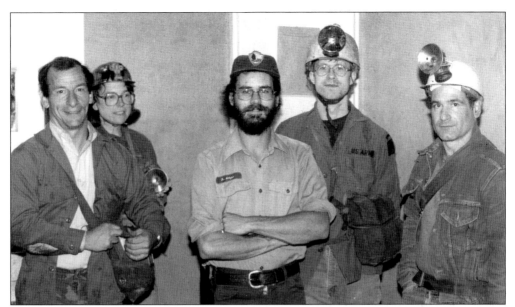

From left to right, Baldwin, Peg Palmer, Ken Allgier, Mike Wiles, and Art Palmer all were on hand for what was to be a gala event, the placing of the 75th mile marker in the cave. The Palmers were experienced cavers and had written a Jewel Cave guidebook. "What is unique about Jewel Cave," Art Palmer says, "is its tremendous size and complexity. It has a grid pattern like a city street, but it's a maze, going every which direction." Allgier had to work and was unable to make the trip. (Courtesy of Mike Wiles.)

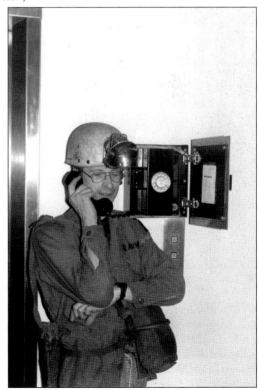

Before descending in the elevator to the caverns, Mike Wiles called the Conns to tell them that the team was about to make history. After the long trip through the Miseries and Mini-miseries and past the Junction Room, the four explorers reached the 75th mile in a place they called Adamantine Alley. (Courtesy of Mike Wiles.)

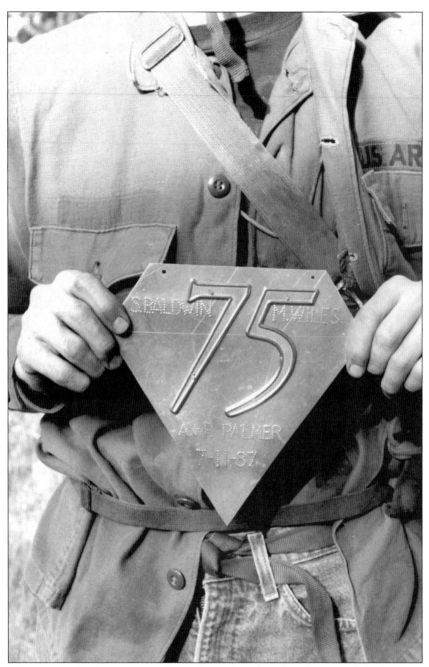

Herb and Jan Conn had made a metal marker to be placed at the spot. It had the explorers' names, the date (July 11, 1987), and the number 75 taken from an old grandfather's clock. When the adventurers began the long crawl back, they came upon several surprises. In the Metrecal Cavern they found a congratulatory card reading, "To the Victorious explorers," along with a bunch of balloons and soft drinks. As they were about to enter the Mini-miseries, they found another card, more balloons, and a big bag of M&Ms. In another room, they came across a third card and a plate of fresh grapes. Unknown to the Wiles team, the Conns, then in their 60s, had made one last trip into the cave to plant the rewards. (Courtesy of Mike Wiles.)

This unusual rock formation is found in Adamantine Alley, to the west of the 75-mile mark. The room was so named not because the gemstones are found there but because the diamond is associated with the number 75, as in a 75th anniversary, Wiles explains. (Courtesy of Mike Wiles.)

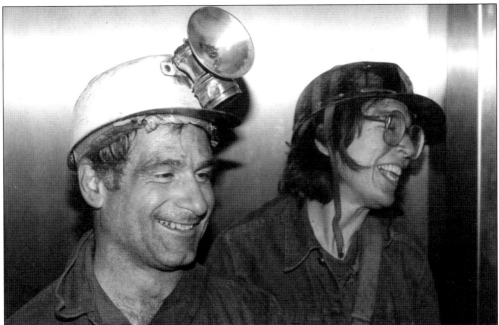

After 15 hours in the cave, during which they surveyed 1,850 feet, the team completed its trip. A weary and dirty Art and Peg Palmer ride up in the elevator. Both Palmers are geologists and recognized speleologists. It was their best cave trip, Art Palmer said later. (Courtesy of Mike Wiles.)

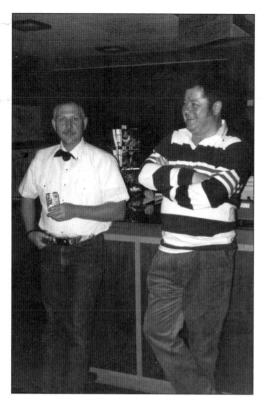

When they exited the elevator in the basement of the visitor center at about 11:30 p.m., the team was cheered by a crowd of fellow employees and cavers and treated to fried chicken. Among the well-wishers were Larry Dilts (left) and Bruce Bitz, a park employee. Art Palmer later remarked, "We thought, Wow, what an achievement. Now, the cave is almost twice that long." (Courtesy of Mike Wiles.)

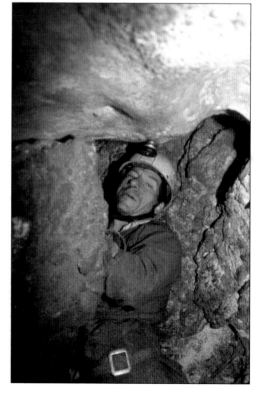

As a boy Steve Baldwin liked rock collecting, and when he was old enough to drive he began looking for caves in the national forest. The attraction is part science and part adventure lust, he says. "NASA has mapped the surface of Mars, so we know what's there, but with a cave you don't know what's inside until you go in." (Courtesy of Steve Baldwin.)

"There's something exciting about the winds in the cave," Baldwin entered in his caving journal in March 1987. "It's not just the ease with which you follow the passage, but it is also the cave communicating with you . . . saying, 'Come this way. No, this way. And this way, and go that way now.'" (Courtesy of Steve Baldwin.)

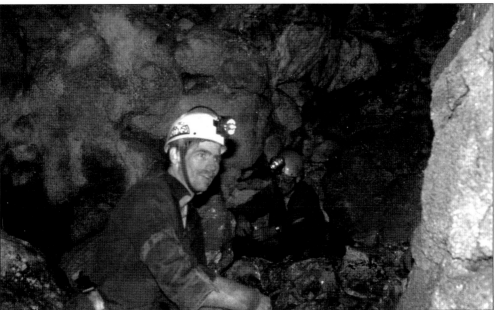

The VACC (Victory After Continuous Contortions) was a breakthrough to the western region of the cave when it was discovered in the late 1980s. Its name stems from the fact that the explorers had to enter the opening on their backs and squirm around pigtail turns, then straight up and through a narrow slot. Pictured at the VACC are Dave Springhetti (foreground) and Mike Wiles. (Courtesy of Steve Baldwin.)

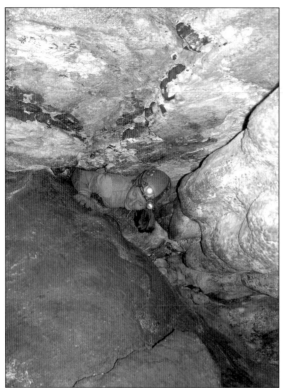

Proceeding from the VACC in the same passage, cavers next encounter the Noble Cause, one of the tightest squeezes in the cave. Small and slender explorers have an advantage. "I have to exhale and push, exhale and push to get through," Steve Baldwin says. Here Rene Ohms, Jewel Cave physical science technician, emerges from the passage. (Courtesy of Mike Wiles.)

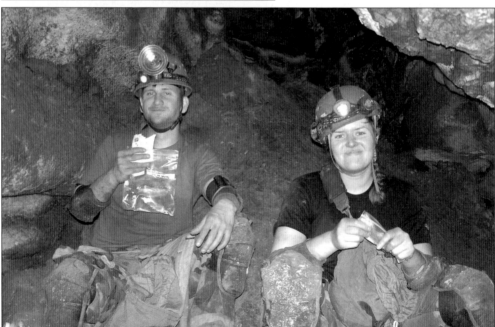

Grueling work requires a hearty meal to sustain energy, but sometimes scrambling over rocks or squirming in crawlways leaves lunch scrunched. Steve Baldwin comments that pebbles got into his food no matter how well he wrapped it. "It makes for a crunchy sandwich." Ben Currens and his wife, Peggy Renwick, seem to be enjoying their snacks. (Courtesy of Mike Wiles.)

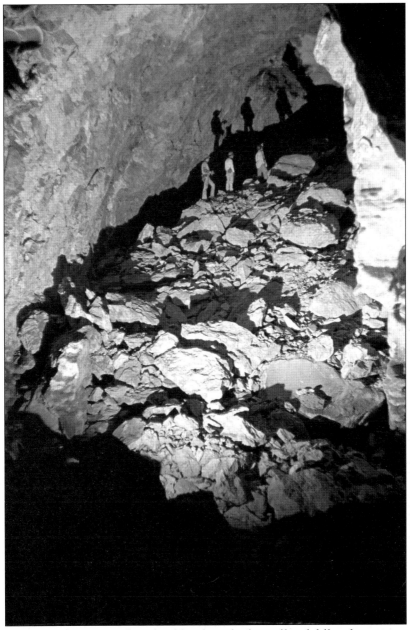

A breakdown zone is an area where boulders have broken off and fallen from cave walls and ceilings to cover the floor. Cavers "push breakdown," working their way through the pile in the hope of finding a lead under the rocks. Baldwin says he once was "lost" for a half hour in breakdown in the Disaster Area. One loses all sense of direction, he says, as "one goes down, around, under, up and over the boulders." What may appear to be a way out turns out to be a void between the rocks. It seemed to him that he was crawling in and out of the same "room" in the rubble, and he began to tire. He called out to his teammates, but they were surveying in another spot. When Baldwin finally extricated himself from the maze, he found that he had never been more than 75 feet from where he had left his partners. This scene is in the Corrigan Passage. (Courtesy of David Schnute.)

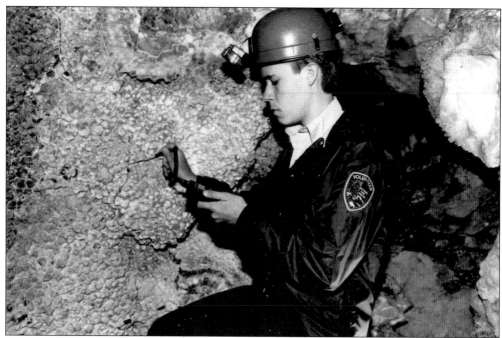

Not everyone in the cave explores. Here D. Kruse, a Volunteer in Parks member, measures cave temperatures in the early 1990s. Both the National Park Service and outside researchers have conducted studies in the cave. (Courtesy of the National Park Service, Jeca 3363.)

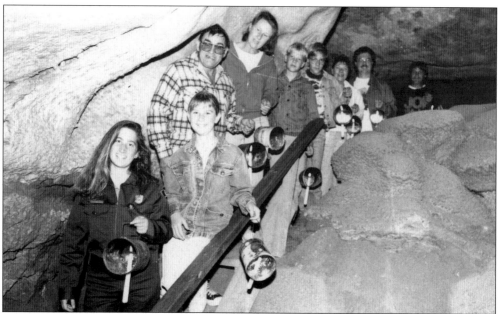

Some visitors choose to see the cave as its discoverers did instead of taking the new scenic tour with its modern lighting. Ranger Michelle Gleicher leads a group in 1991 on a candlelight tour from the historic entrance. Candles were replaced with oil lanterns in 2003 because wax from dripping candles caused mold problems in the cave. (Courtesy of the National Park Service, Jeca 3012.)

Visitors who opt for the lantern tour first assemble at the ranger cabin in the historic area. After they receive their lanterns, they follow the ranger down the hill to the original entrance. In this 1991 photograph, a group is about to enter the cave. (Courtesy of the National Park Service, Jeca 2666.)

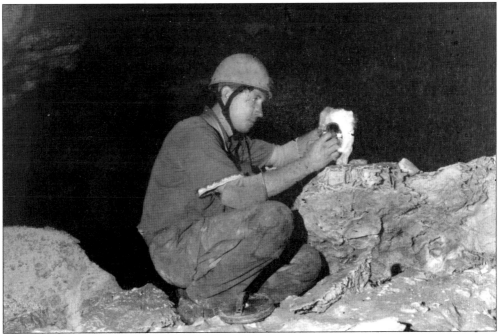

Myk Coughlin uses carbide from a lamp to make a label for a survey station in the early 1990s. While most cavers use battery-operated LED lamps today, some insist that carbide lamps provide better lighting. (Courtesy of Mike Wiles.)

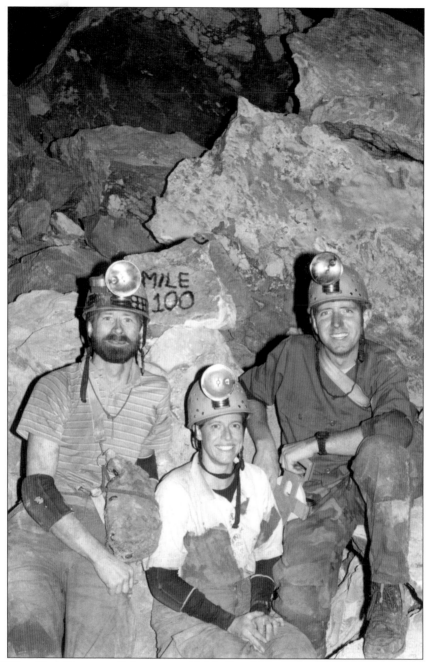

Mike Wiles, Cori Giannuzzi Schwartz, and Myk Coughlin reached the 100-mile mark in June 1994. Once again, on their way back the team found congratulatory signs. More esoteric than the Conns' had been, they included, "More crystals than Carlsbad," "Windier than Wind Cave," and "More manganese than Mammoth." In a gesture of respect, some of their spelunker friends met the explorers on the trail and carried back their packs for them. Although they did not make it back until about 2:00 a.m., the cave staff awaited them with cake and ice cream. All exploring is done on a volunteer basis. Even park employees do their adventuring on their own time. (Courtesy of Mike Wiles.)

Jan Conn (left) congratulates Cori Giannuzzi Schwartz and Mike Wiles on their accomplishment. The mileage sign (upper left corner) displayed in the visitor center has been a tradition since the 1970s when Al Hendricks was unit manager. "Every time the Conns went into the cave, Herb would call me the next day and say, 'Change the sign,'" Hendricks says. (Courtesy of Mike Wiles.)

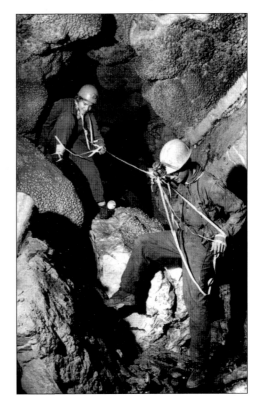

Martha Nitzberg and Mike Wiles tangle themselves in measuring tape, demonstrating that surveying is not so easy. Because the cave is a three-dimensional maze, explorers sometimes excitedly follow a new lead only to find that they have come by a roundabout way back to an area they previously mapped. (Courtesy of Mike Wiles.)

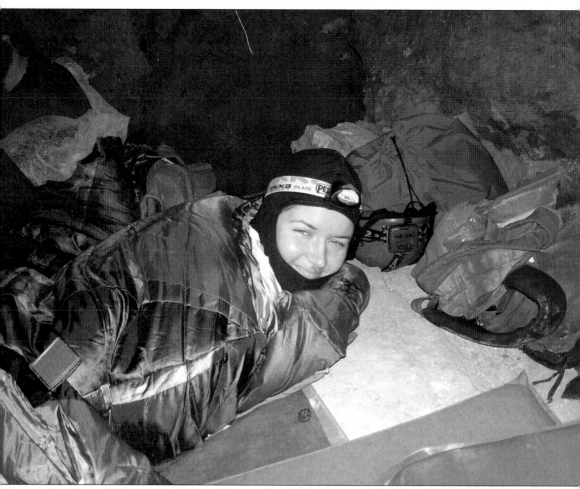

Explorers did day-trips until it took more than 18 hours to get to virgin territory and back. Since 1996, Mike Wiles has been leading three- or four-day trips. At this writing, the cavers make camp when they still are about four hours from the area they want to map. Sleeping bags, a camp stove, and a few other items, such as knee and elbow pads, are brought out ahead of time. Energy bars, dried fruit, jerky, and freeze-dried meals are standard fare, and water is available in the cave. Garbage and human waste must be carried out. "We limit our trips to four days because urine has to be kept in plastic bottles and carried out, and four days' worth is about what we can carry," Wiles says. Here Peggy Renwick, a cave management intern, awakes to another day of caving in January 2004. (Courtesy of Mike Wiles.)

Jan Conn was working her way through this uninviting eight-inch-high crawlway on her way out of the cave when she commented that the stretch closely resembled another spot near the entrance. "Wouldn't it be nice," she asked, "to just press a button and be back at the elevator?" Teammates later dubbed it the Teleportation Machine, and someone placed an "Out of Order" sign at the spot. (Courtesy of Steve Baldwin.)

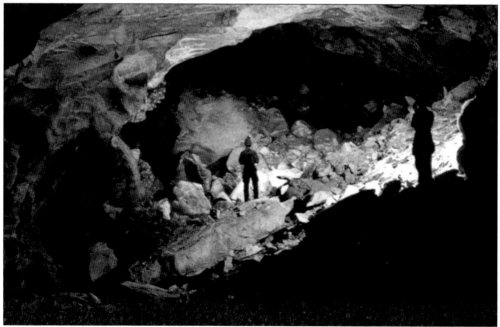

A team of explorers enters the Side Track. This passage, which connects to Cloud Nine, is one of the few places in the southeastern part of the cave where drip water can be collected for drinking. The availability of water makes further exploration in the area a little easier. (Courtesy of Marc Ohms.)

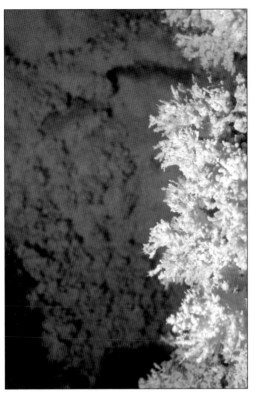

One of Steve Baldwin's favorite places in the cave is Christmas Pass, where this beautiful aragonite frostwork over cave popcorn adorns the walls. Baldwin is executive director of the Black Hills Parks and Forests Association, which operates book stores in local parks. He lives in Custer. (Courtesy of Steve Baldwin.)

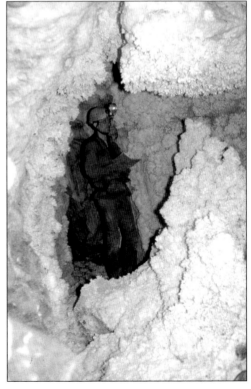

Mike Wiles admires a favorite speleothem, a five-foot-tall "Christmas tree." Christmas Pass is an approximately 20-foot-by-15-foot room almost completely coated with glittering frostwork. It seems especially festive because "it is located in a part of the cave where most of the walls are gringy, dirty rock," Baldwin says. (Courtesy of Steve Baldwin.)

Jewel Cave employs a hazard fuel reduction program to protect the buildings from forest fire. Daryn Witt uses a chainsaw in 1991 to thin a stand of ponderosa pines east of the access road. (Courtesy of the National Park Service, Jeca 2663.)

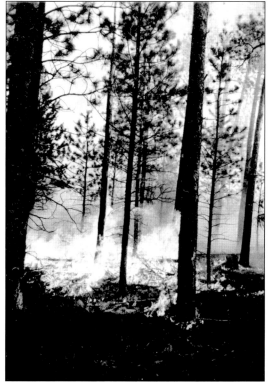

The controlled burn, such as this one conducted in 1990, is another way to discourage the spread of fire. The preventive measures proved their worth in 2000 when a major forest fire destroyed much of the area around the cave. (Courtesy of the National Park Service, Jeca 2639.)

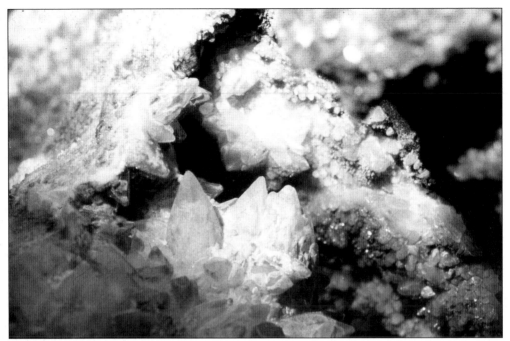

It is not difficult to see why this formation is known as "dog tooth spar." Composed of calcite crystals, the speolothem is a six-sided polyhedron. These specimens are located in the Crystal Display Room on the Hub Loop. (Courtesy of Steve Baldwin.)

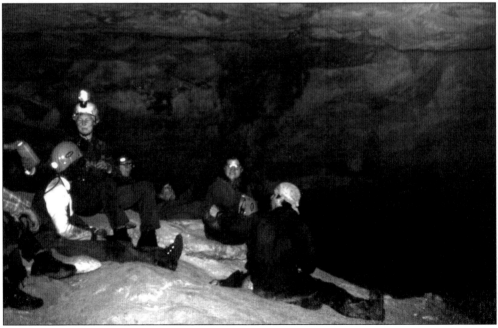

Photographers use various techniques to brighten cave rooms for the camera, but most of the time cavers have only their helmet lamps to light the way. These explorers are taking a break in the Hub. As part of the scenic tour rangers turn off the electric lights on the route for one minute so that visitors may experience the total darkness of the cave. (Courtesy of Steve Baldwin.)

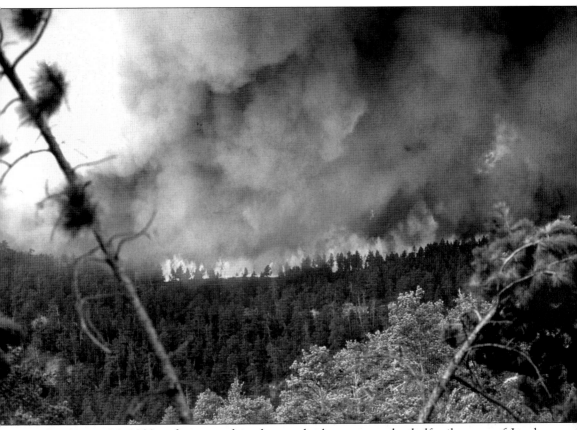

On August 24, 2000, a fire erupted in the woods about two and a half miles west of Jewel Cave. Due to the hot, dry, windy weather, the fire spread quickly in Black Hills National Forest. It consumed nearly 84,000 acres of timber, spreading over about 90 percent of Jewel Cave National Monument. Burning at 100 acres a minute, the blaze spread eastward, causing parts of Custer to be evacuated. But that night the wind changed and blew north, sparing the town. Firefighters, sometimes as many as 1,160 at a time, battled the blaze for more than two weeks before containing it. Fire crews foamed the historic ranger cabin several times as the blaze burned around it. The administrative staff temporarily moved some valuables inside the cave for safekeeping. No buildings were lost in the park, and elsewhere only a cabin and several outbuildings were destroyed. (Courtesy of Paul Horsted.)

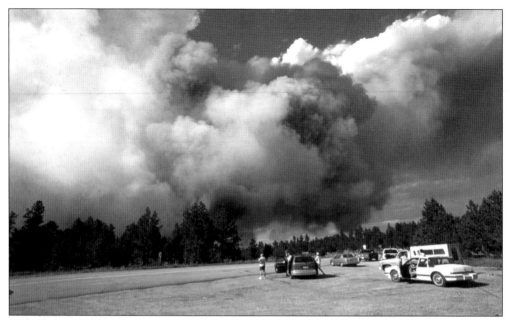

The blaze, called the Jasper fire because it started on Jasper Cave Road, could be seen for many miles and brought onlookers from throughout the Black Hills. Among them was Custer photographer Paul Horsted. He is the author of several books on Black Hills history, including *The Black Hills Yesterday and Today,* and coauthor of *Exploring with Custer: The 1874 Black Hills Expedition.* (Courtesy of Paul Horsted.)

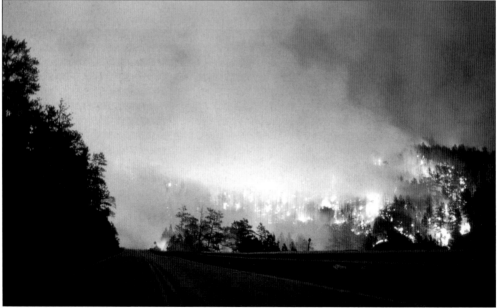

At night, the fire glowed eerily. No human lives were lost, and most large wild animals survived. Firefighters reported seeing deer and elk fleeing from the area. Animals known to have perished include a radio-collared mountain lion, an elk, and several deer. Wildlife officials estimate that many smaller animals, such as porcupines, skunks, and rabbits, suffered heavy losses. Only one domestic animal, a cow, was lost. (Courtesy of Paul Horsted.)

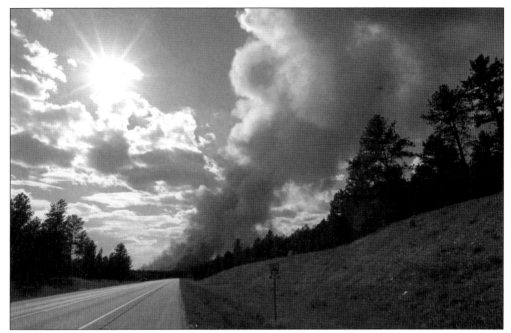

Todd Suess, Jewel Cave superintendent, credited the park's fire management program with saving the visitor center and other buildings from damage. He said the prescribed burns conducted earlier had removed heavy stands of dog hair pine, which otherwise might have fueled the fire, from around the structures. (Courtesy of Paul Horsted.)

The blaze was the result of arson. According to Phil Geenen, fire investigator for the USFS, it was set in a slash pile like this one. Loggers and individuals who thin trees or brush pile up branches and other debris. The slash piles are burned in the winter after a snowfall cuts the risk of the fires spreading. (Courtesy of Phil Geenen.)

Geenen says that the blaze began about 100 yards from Highway 16. A man who lived in the area reported that he had seen a white minivan turn onto the highway from Jasper Cave Road, and moments later he witnessed what appeared to be an explosion in the woods. The following day, Geenen learned that another law enforcement officer had seen a woman suspected in several suspicious fires driving a steel gray minivan in the area shortly after the fire started. (Courtesy of Phil Geenen.)

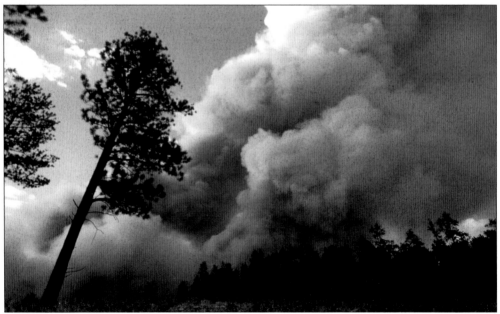

Later Geenen received a tip that two women who had been driving on Highway 16 had seen a gray minivan turn onto Jasper Cave Road shortly before the fire erupted. One of the witnesses recognized the vehicle as belonging to the suspect, a Newcastle woman. Geenen interviewed her and noted discrepancies in her story. He called USFS criminal investigators, who placed her under arrest. (Courtesy of Paul Horsted.)

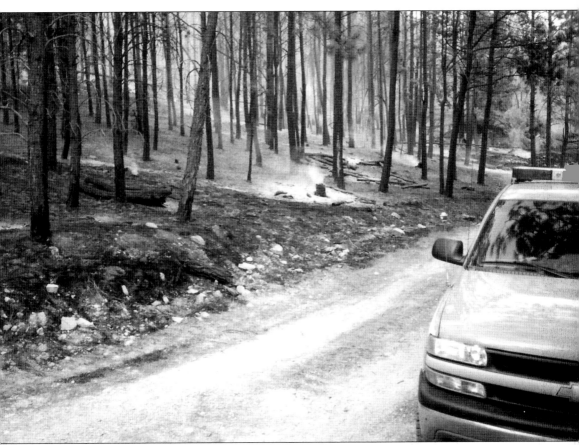

The investigation revealed this spot to be the point of origin of the fire. Geenen says that he found "grass stem indicators" at the scene. A fire burns with great intensity in the direction the wind is blowing, completely destroying the grass in its path, Geenen explains. However, it burns slowly in the direction from which the wind is coming. Individual blades of grass do not burn completely, and they bend toward the point of origin. The evidence refuted the suspect's story, Geenen says. She reportedly identified another spot as the site of the fire after claiming that she had started it accidentally while smoking. She allegedly told investigators that she had dropped a match, which ignited the grass. However, Geenen says that when he interviewed the woman, she had lit several cigarettes with a lighter. The woman eventually was found guilty of arson. At this writing, she is serving a 10-year sentence. (Courtesy of Phil Geenen.)

Local people who enjoyed hiking or horseback riding in Hell Canyon were devastated by the loss. Among them was Martha Studt, a Custer artist. A few weeks after the fire, she and a few friends went on a trail ride in the area. What Studt saw was not as upsetting as she had feared. (Courtesy of Martha Studt.)

"I was absolutely shocked by the artistry of it," she says. "I forgot about being depressed and got really excited about the possibilities for photography." Studt, who spent one summer working in the book store at Jewel Cave, returned with her camera again and again over the next few months. (Courtesy of Martha Studt.)

Studt says the charred forest had a "different feel" each time she went. "There was so much variety. After it snowed, there was so much contrast. The trees looked incredibly black." Studt also enjoys painting. Her themes vary from wildlife to the abstract. (Courtesy of Martha Studt.)

"In some areas, the trees were very linear. Some places looked like war zones. The branches made me think of barb wire. In other spots, there was dense, tangled undergrowth," she says. While employed at Jewel Cave, Studt tried spelunking. For her, the hardest part was an uphill climb. "I used muscles I hadn't used before," she relates. (Courtesy of Martha Studt.)

According to Todd Suess, who came to Jewel Cave in 2001, prescribed burns were scheduled for 2008 to clear the woods of dead trees and identify areas to be maintained as meadows. Suess also plans to install new airlock doors at the entrance to protect the cave and create new exhibits in the visitor center. (Photograph by the author.)

Park employees still are cleaning up and repairing fences damaged by the fire. Part of the Jewel Cave maintenance crew is pictured in this 2003 photograph. From left to right are Nick Oster, Jeremiah Tibbits, Mike Carder, Rob Thomas, Phil Clark, and Joe Speckles. (Courtesy of Miriam Gola.)

Some of the ladies of the administrative staffs of Jewel Cave and other parks have an outing at a Hill City restaurant in December 2003. Clockwise from left to right are Susan Buttery, Wind Cave National Park; Jill Hart, Jewel Cave; the late Sandy Meyer, Wind Cave National Park; Beckie Carder, then at Mount Rushmore National Memorial and now at Jewel Cave; Ann Beckham, Mount Rushmore National Monument; and Miriam Gola, Jewel Cave. (Courtesy of Miriam Gola.)

Repairs to the 1935 ranger cabin were made in 2002. In keeping with its goal to preserve the historic appearance of the area around the original entrance, the park may remove some unnecessary roads and structures, including a lantern storage shed. Future plans also include upgrading trails, a new visitor services building in the historic area, and a shuttle system between the visitor center and the historic district. (Courtesy of the National Park Service, Jeca 3115.)

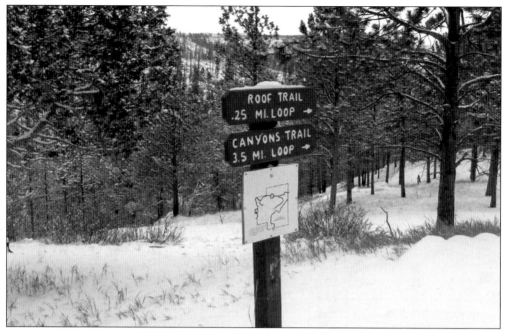

Park visitors may hike a three-and-a-half-mile loop between the visitor center and the historic area. The trail passes through Lithograph and Hell Canyons and past the original entrance. A quarter-mile roof trail does not descend into the canyons. This scene is just a few steps from the visitor center entrance. (Photograph by the author.)

At the bottom of Lithograph Canyon, a mule deer doe gazes thoughtfully at the author before bounding up the hill. Other wild animals often encountered in the park include elk and bighorn sheep. A lucky visitor may see a bald eagle or an elusive mountain lion. (Photograph by the author.)

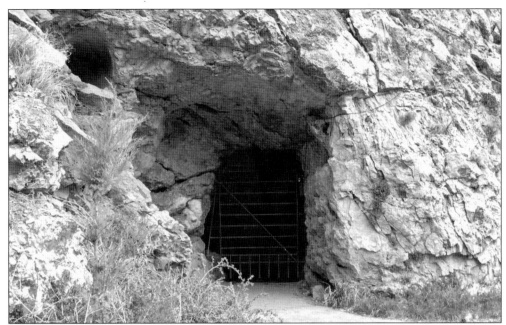

The park is visited by some 88 species of birds, including hawks, owls, ducks, herons, grouse, orioles, and mountain bluebirds. From Hell Canyon, hikers proceed uphill to the original cave entrance. On a warm day, the cold air emanating from the cave provides welcome relief. (Photograph by the author.)

From the cave entrance, visitors proceed on a winding concrete sidewalk to the stone stairway constructed by the CCC. The steps lead to the ranger cabin and the tour assembly area. There are benches along this part of the route where visitors may rest before making the climb. (Photograph by the author.)

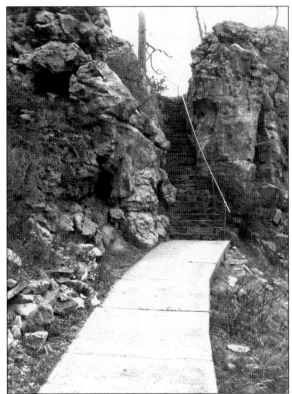

The upper part of the trail offers some spectacular views of the canyons. For those who pack a lunch, there is a picnic area near the ranger cabin. From the historic area it is a short hike over a ridge to return to the visitor center and main parking lot. (Photograph by the author.)

Just outside the visitor center entrance is a small 8.5-inch-high-by-24-inch-wide concrete block by which the more adventurous may test their caving abilities. Those who want to take a spelunking tour must be able to pass through the narrow opening. (Photograph by the author.)

Dave Love, the author's husband, has maneuvered his head and upper torso through the rectangle and is wriggling to clear the rest of his body. Even though he is five feet, seven inches tall and slim, he had to remove his bulky belt buckle to pass through. The block represents the tightest squeeze on the tour. (Photograph by the author.)

Todd Suess says that it long has been proposed to move Highway 16 farther north so that it does not pass over the cave. Oil and other emissions from vehicles seep through the road and fractures in the rock and eventually make their way into the cave. The project would entail constructing a bridge over Hell Canyon and is not likely to be undertaken in the near future. The photograph shows Highway 16 (in the background) as it passes the main entrance. (Photograph by the author.)

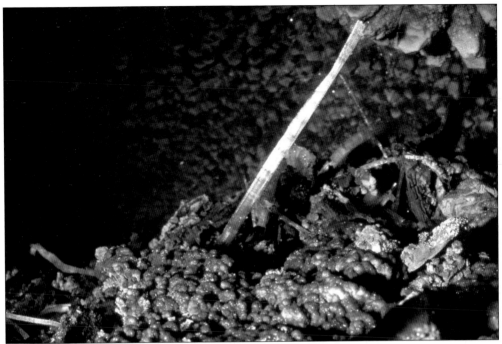

Gypsum needles frequently are found in the lower passages of the cave. Some are as thin as hairs and so fragile that when a person approaches too closely the slight current of air created by body heat is enough to make the needles quiver. (Courtesy of Steve Baldwin.)

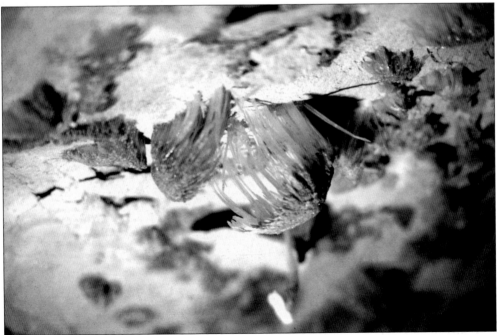

When needles grow in clusters, they are known as gypsum spiders. In a dark cave, they may appear somewhat like arachnids or, perhaps, crabs. These specimens are found along the Hub route. (Courtesy of Steve Baldwin.)

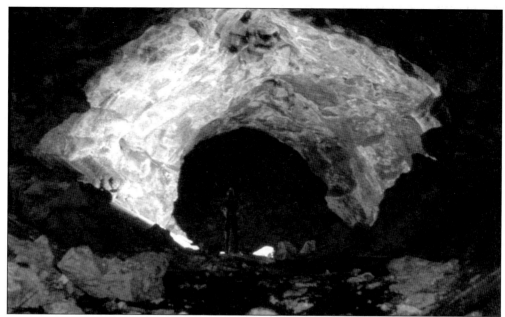

There are two reasons why this passage was dubbed the Loose End, according to Marc Ohms, Wind Cave National Park physical science technician. First, at the rear of the passage explorers found a sole 25-foot-long gypsum "hair" that extends from floor to ceiling, and second, when the room first was entered, its discoverers decided to leave it unexplored until a later date. (Courtesy of Marc Ohms.)

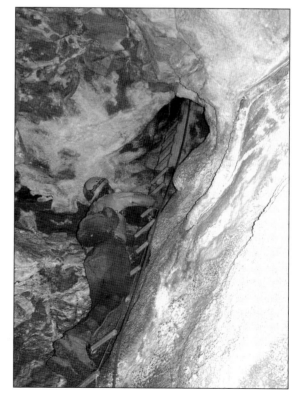

Jason Walz, a seasonal employee, climbs down into the Point of No Return in January 2004. The passage got its name because when explorers first descended through the opening they had a difficult time getting back up. Finding this lead led to the discovery of Cloud Nine and other large rooms in the southeastern part of the cave. (Courtesy of Mike Wiles.)

The dark interior of a crystal-coated passage is enticing to serious cavers who always wonder what lies beyond. Todd Suess describes the cave with its many twists and turns as "a bowl of spaghetti with chunks of layer cake in it." (Courtesy of Steve Baldwin.)

Evidence of the Conns' splendid sense of humor still can be found in the cave. They left this "Walk In" sign at the Calorie Counter, where the Miseries become the Mini-miseries. Mike Wiles demonstrates how ludicrous the sign is. The crawlway averages only 12 inches high for some 900 feet. (Courtesy of Steve Baldwin.)

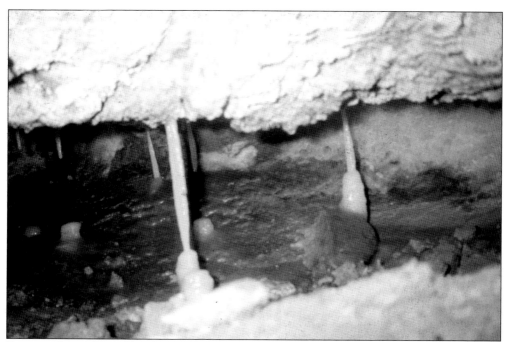

Even inside crawlways like the Mini-miseries there is beauty. But to see these slender "columns" in this tight spot, Baldwin says, a caver has to enter with his head already tilted to the left. Columns are formed when stalagmites and stalactites connect. (Courtesy of Steve Baldwin.)

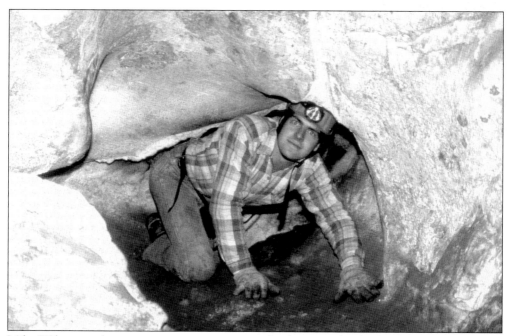

Mike Wiles says that as cave management specialist he uses what he has learned to help and prepare those new to caving. Tim Behlings is a Rapid City Fire Department investigator and one of the volunteer explorers. He is seen here crawling in a sub chert level passage. (Courtesy of Steve Baldwin.)

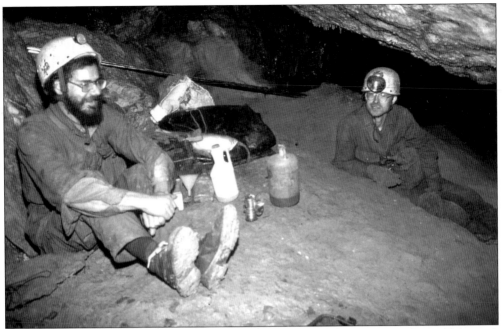

Ken Allgier (left) and Mike Wiles stop for supplies at the "well hole" in Hell's Half Acre. A six-inch-diameter hole was made in the ceiling so that supplies could be lowered from above. The project made it possible to explore the western portion of the cave without having to carry supplies and equipment in and out each day. (Courtesy of Steve Baldwin.)

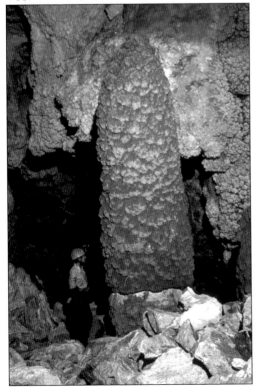

R. J. Hall, a room that bears the name of a cave explorer, is home to a number of popcorn stalagmites. Most are from 8 to 10 feet tall, but this one is an impressive 18 feet tall and about 4 feet in diameter. Cori Giannuzzi Schwartz looks in wonder at what Jewel Cavers believe to be the world's tallest logomite. (Courtesy of Marc Ohms.)

A visit to Jewel Cave was on the agenda in July 2004, when the Michauds and their relatives by marriage, the Jenniges family, held a reunion in the Custer area. The photograph was taken at the picnic area in the historic area. Seen here are Nettie Michaud, Katelyn Weldon, Seamus Hall, Mary Michaud, Eileen Crouch, Patricia Tracy, Beau Walker, Frank Michaud, Renee Michaud, Monica Weldon, Ramona Michaud, Heather Walker, Michael Michaud, Megan Michaud, Nancy Michaud, Sarah Nuhiden holding Devin Nuhiden, Jeff Weldon holding Helen Weldon, Leslie Weldon, Monita Nemitz, Janna Michaud, Celeste Locke, Marie Wickersham, Mary Erdahl, Shane Tracy, Lisa Miguel, Marie Octradovec, Jimmy Jenniges, Peter Jenniges, John Jenniges, James Michaud, Leland Jenniges, Tony Jenniges, Tom Jenniges, and Joe Michaud. (Courtesy of Monica Michaud Weldon.)

Today little remains of the Michaud era at the cave except for these ruins of the 1900 log house, located along Highway 16, near the entrance road for the historic area. The log house and other Michaud structures were burned down and removed by the CCC. In a 1989 interview, Ira Michaud said that after he heard about the removal he made a trip back to the cave. "Can you imagine the affect . . . when I arrived at the spot . . . and there was nothing but a pile of blackened logs and ashes?" he asked. "Something went out of my very being when I viewed this scene of destruction, and now, 50 years later, that something has never really been replaced." (Photograph by the author.)

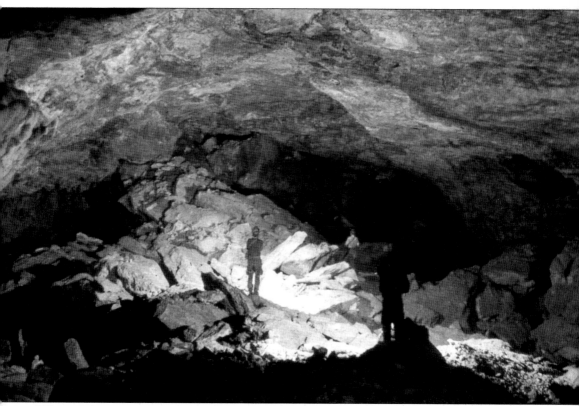

When explorers came upon Wanderland in the 1980s in what was then the western extent of the cave, it was the largest room yet discovered. Mike Wiles says the room earned its name when he became separated from his teammates and did a lot of "wandering back and forth" before meeting up with them again. Wanderland (pictured above) held the title until 1994 when cavers made their way first to Cloud Nine, whose name describes the way the explorers felt that day, and later to the even larger Big Duh. According to Rene Ohms, no one was able to think of an appropriate name for such a grand room, "So we began referring to it as the 'Big Duh,' and the name stuck." Big Duh, discovered at about the same time that the Wiles team reached the 100-mile mark, is some 600 feet long, 90 to 100 feet wide, and 30 feet high. At this writing, it still is the largest room in the cave. (Courtesy of Marc Ohms.)

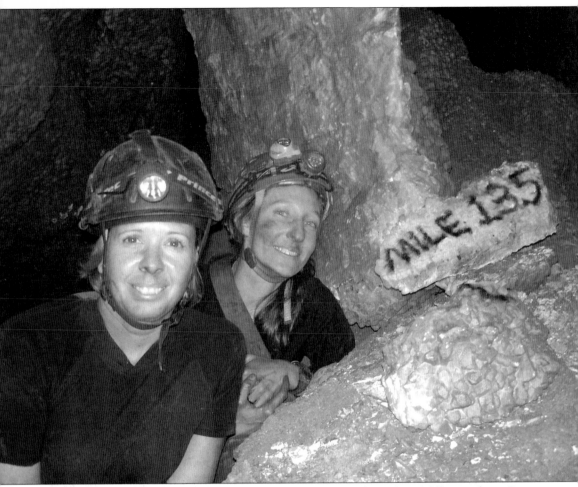

In January 2006, Andy Armstrong, cave management intern; his wife and fellow explorer, Bonny (left); and Rene Ohms reached the 135-mile mark, making Jewel Cave the second-longest cave in the world. Todd Suess and others on the administrative staff had kept tabs on the progress of the 133-mile-long Optimistychna Cave, then in second place. Suess urged the team to push on to 135 miles, Ohms says, because he wanted to be sure Jewel Cave unquestionably was ahead before claiming the title. Optimistychna is a mazelike gypsum cave in the Ternopil district of the Ukraine. The longest cave in the world is Mammoth Cave, located in southwestern Kentucky with 367 mapped miles. Wind Cave, with 127.8 miles, is fourth longest. (Courtesy of Mike Wiles.)

Dan Austin (left), a seasonal employee at Jewel Cave; Andy Armstrong (center); and Stan Allison, a Carlsbad Caverns employee, consult the survey book near the Dark Descent in October 2005 to determine the day's activities. (Courtesy of Mike Wiles.)

Like the Conns, Larry Shaffer was a rock climber before he began volunteering at Jewel Cave. According to his fellow cavers, he is a "computer guy" as well. He is pictured in February 2006 near P. C. Junction and the 140-mile marker in the far southeastern part of the cave. (Photograph by Andy Armstrong; courtesy of Mike Wiles.)

New signs along Highway 16 and at the park entrance in 2008 herald Jewel Cave's 100th anniversary as a national monument. The criteria of "scientific interest" and promoting the "public interest" by which Pres. Theodore Roosevelt justified protecting and preserving the cave hold true today. (Photograph by the author.)

A year of special events is planned to celebrate the centennial, Todd Suess says. The first, held in February, featured a program of cave slides and songs by the Conns, now in their 80s. From left to right are Mike Wiles, Jan and Herb Conn, and Andy Armstrong. (Photograph by the author.)

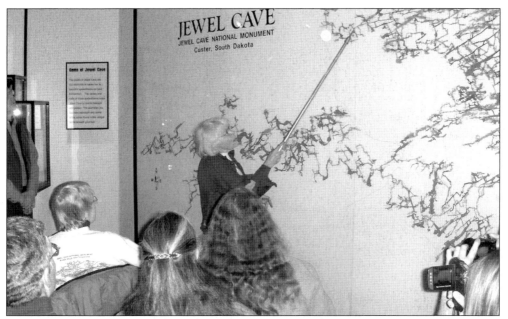

During the lecture, Jan Conn used the visitor center's wall-sized map to point out how construction work altered the interior of the cave. She said that water drainage patterns changed, with the result that some parts of the cave are more humid and others drier than they were before development. She added, "There still are about 140 miles of cave just as wild as it always was, and that probably is not going to change." (Photograph by the author.)

The free program included a piece of centennial cake and coffee. Suess said that throughout the year there will be free tours and ranger-led hikes. Also planned are special events for cavers and an employee reunion. (Photograph by the author.)

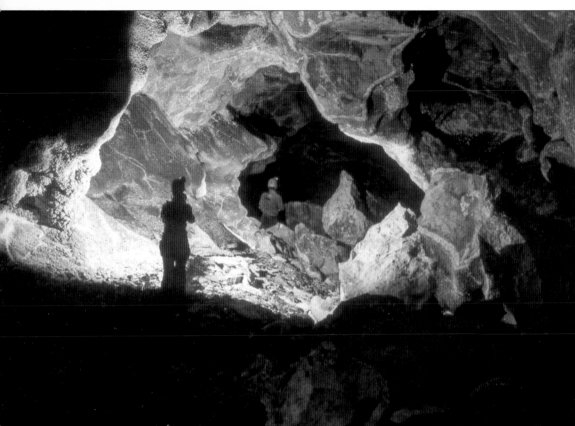

Explorers sometimes use a hand line to climb from Cloud Nine about 20 feet up into this passage, dubbed the Short Cut, which intersects with the Loose End. Jewel Cave now measures almost 142 miles of surveyed passages. And the cave continues to grow. Mike Wiles estimates that only about five percent of the cave so far has been mapped. A German scientist who studied air flow dynamics in the cave calculated that there is enough wind volume for Jewel Cave to connect to Wind Cave. They are separated by some 35 surface miles. Although no such connection has been found, the Pahasapa Limestone layer in which Jewel Cave is contained extends all the way to Wind Cave. "We believe that even if they don't connect, both caves may have thousands of underground miles still waiting to be discovered," Wiles says. (Courtesy of Marc Ohms.)

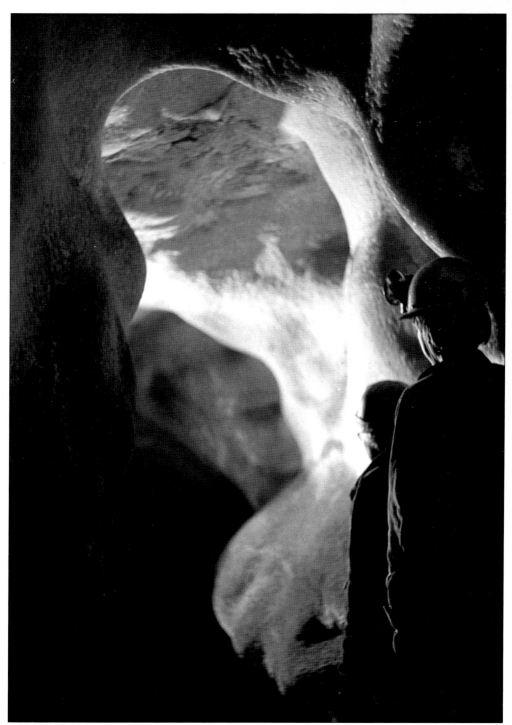

The splendor of Jewel Cave is perfectly captured by Herb Conn in *The Jewel Cave Adventure*: "A Chorus of Crystals / A travertine cast / The footlights are mounted / And lighted at last. / The curtain will rise / On a scenic tableau. / Come to the cave / For a Jewel of a show!" (Courtesy of David Schnute.)

Across America, People are Discovering Something Wonderful. Their Heritage.

Arcadia Publishing is the leading local history publisher in the United States. With more than 3,000 titles in print and hundreds of new titles released every year, Arcadia has extensive specialized experience chronicling the history of communities and celebrating America's hidden stories, bringing to life the people, places, and events from the past. To discover the history of other communities across the nation, please visit:

www.arcadiapublishing.com

Customized search tools allow you to find regional history books about the town where you grew up, the cities where your friends and family live, the town where your parents met, or even that retirement spot you've been dreaming about.